AN INTRODUCTION TO
WATERCOLOR

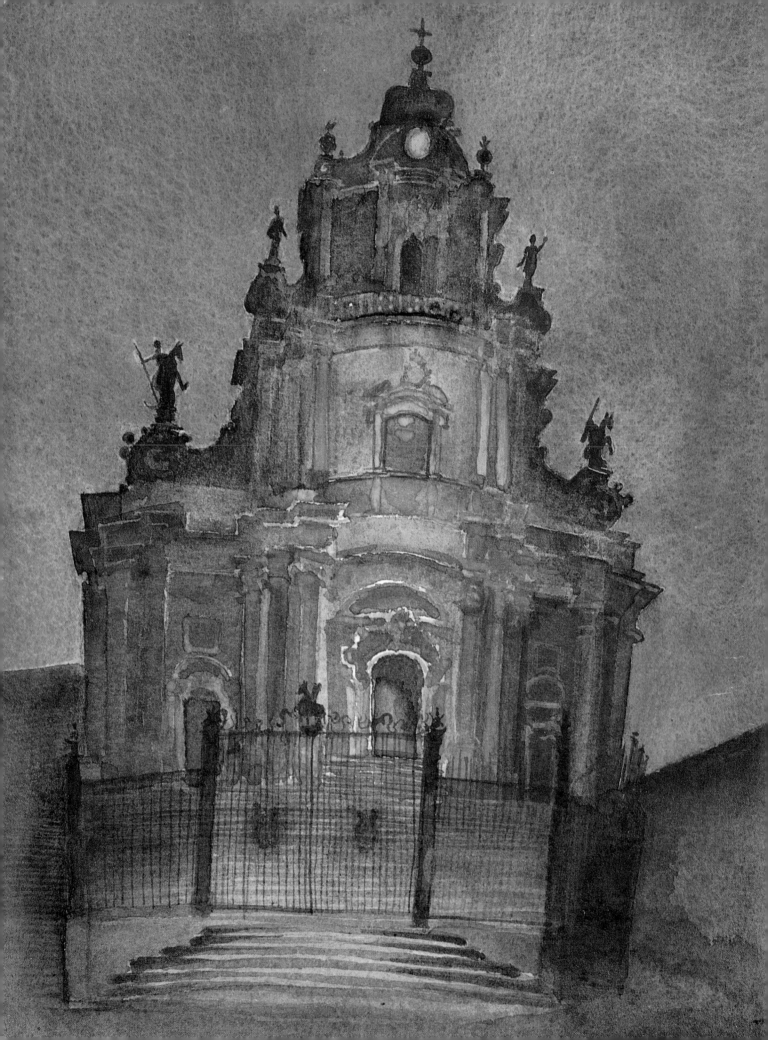

The DK Art School

AN INTRODUCTION TO
WATERCOLOR

RAY SMITH

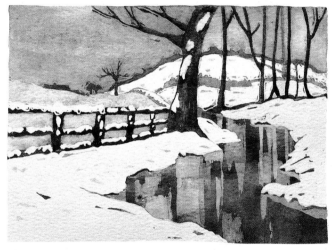

 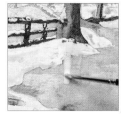

DORLING KINDERSLEY
LONDON • NEW YORK • STUTTGART
IN ASSOCIATION WITH THE ROYAL ACADEMY OF ARTS

A DORLING KINDERSLEY BOOK

Project editor Emma Foa
Art editor Claire Legemah
Assistant editor Joanna Warwick
Design assistant Dawn Terrey
Senior editor Gwen Edmonds
Senior art editor Toni Kay
Managing editor Sean Moore
Managing art editor Tina Vaughan
US editor Laaren Brown
DTP manager Joanna Figg-Latham
Production controller Helen Creeke
Photography Phil Gatwood
Additional photography by Susanna Price,
Tim Ridley, Steve Gorton, Andy Crawford

First American Edition, 1993
2 4 6 8 10 9 7 5 3 1

Published in the United States by
Dorling Kindersley, Inc., 232 Madison Avenue
New York, New York 10016

Copyright © 1993
Dorling Kindersley Limited, London

Library of Congress Cataloging-in-Publication Data

Smith, Ray, 1949-
 An Introduction to Watercolor / Ray Smith. -- 1st American ed.
 p. cm. -- (The DK Art School)
 Includes index.
 ISBN 1-56458–274–4
 1. Watercolor painting--Technique. 2. Color in art. I. Title.
II. Series.
ND2420.S62 1993
751.42'2--dc20 92-37404
 CIP

Color reproduction by Colourscan in Singapore
Printed and bound in Italy by Graphicom

CONTENTS

WATERCOLOR

OF ALL THE VARIOUS PAINTING MEDIA, including oils and acrylics, watercolor is by far the most convenient to work with. It has the range and adaptability for almost any kind of painting situation or style. All you need to get started is a small watercolor box, a couple of brushes, a pad of paper, and some water. When you look at a watercolor painting, you can see how it was painted, as well as getting a sense of the artist through the kinds of marks that have been made. This is because the nature of the watercolor painting method is such that almost nothing can be concealed in the painting. Unless you are using gouache paints (*see* pp.64-5), you cannot paint over something in order to conceal it, the way you can when you are painting in either oils or acrylics.

Picking up tips

What this means is that it is possible, just by looking at a painting carefully, to make a reasonably accurate guess at the means by which a particular effect was achieved. The implications of this are that anyone with a little experience and sense of how the medium works should be able to look at the watercolor paintings of artists they admire and pick up useful practical information. For this reason, each section of the book ends with a "gallery" of relevant paintings with examples of both historical and contemporary artists.

The power of transparency

What makes it possible to "read" a painting is that the watercolor medium is, above all else, a transparent painting medium. It relies for most of its effects on the fact that rays of light penetrate the watercolor paper and are reflected back to the viewer through the transparent paint film. The more the paint and the darker the washes, the less light is reflected back. In an opaque painting system, the rays of light would be reflected back off the surface of the paint itself rather than the paper, because the paint is too dense for the rays of light to penetrate. There is an opaque watercolor system based on gouache paint or bodycolor, and we shall be considering this later. There are also uses for bodycolor in largely transparent painting techniques where, for instance,

the artist may be working on an off-white or colored paper and wishes to put in a white highlight. Purist watercolor painters have tended to avoid the use of bodycolor, favoring overlaid washes of transparent color, and using the white of the paper itself for highlights.

Drawings and color washes

At its most basic, the watercolor medium provides an effective and "clean" method of applying color washes to a pencil drawing. For many artists, this is the very first stage in the development of their practical knowledge of paint and painting. It is an excellent starting point because, used in this way, watercolor is not at all intimidating and, with a little practice, the results can look extremely competent. A simple drawing can be transformed by the addition of a couple of washes of color. It is important for beginners to realize that if they start in this way and follow a few basic guidelines, they can achieve a surprising degree of expertise in a relatively short time.

Getting started

This book is designed to introduce the medium, its tools, and techniques in a way that is practical and accessible. The Brief History that follows sets watercolor painting in its historical perspective, while the many "tips" boxes give you a handle on painting technique. The most essential element in all this is that you enjoy what you are doing. Always paint the things that you want to paint, not the things you imagine you ought to paint. You will no doubt get frustrated at times – all painters do – but keep practicing or try another approach until you get it right. Remember too that the quality of your materials is important – you cannot paint a fine line if your brush does not come to a point, and thin paper will buckle if it has not been stretched. Having said all that, it is time to look at some fine historical examples of watercolors, and start painting.

Good luck!

A BRIEF HISTORY

THE FLOWERING OF WATERCOLOR PAINTING in Great Britain toward the end of the eighteenth century tends to foster the idea that this was when watercolor painting began. In fact, artists had been using water-soluble binding materials with pigments for centuries. As early as the end of the fifteenth century, Albrecht Dürer *(1471-1528)* produced a remarkable series of landscape paintings that can rightly be called watercolors. Dürer used water-soluble paints on parchment or on paper, overlaying transparent colors and using the color of the paper for the lights.

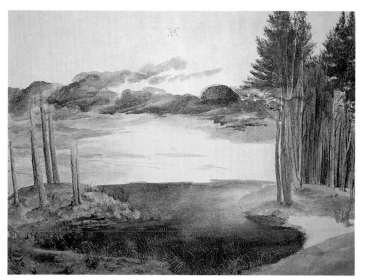

Albrecht Dürer, *Lake in the Woods,* **1495-97**
The brooding atmosphere of this famous early watercolor landscape gives it a particularly contemporary feel, with the trees on the left appearing to be blasted by war. The scene is deserted, as if not a human being is left alive.

THE SEVENTEENTH CENTURY saw a number of monochromatic drawings in pen and ink and wash, or simply in brush and wash, by such artists as Nicolas Poussin *(1594-1665)* and Claude Lorrain *(1600-82)*. These studies may not be categorized technically as watercolors, yet they are very much the forerunners, in style and technique, of the work of later watercolor painters.

Toward realism

Wenceslaus Hollar *(1607-77)* was an artist from Prague who settled in England in 1636. His panoramic views of English towns and coastlines were an attempt to make faithful representations of places, rather than to create the kinds of imaginary classical landscape we associate with artists like Claude Lorrain.

Among other artists working in this way was Francis Place *(1647-1728)* who, in addition to his many panoramic works, produced a fine series of pen and wash drawings from nature – all characterized by a fluent and highly assured use of brush and wash.

The mid- to late eighteenth century saw the emergence of a number of painters who chose to concentrate on watercolor as their preferred medium. Paul Sandby *(1725-1809)* was one of the first British artists to recognize and fully exploit the potential of the medium in works that incorporated both transparent and bodycolor techniques. His architect brother Thomas *(1723-98)* was also a fine watercolor painter who had some skill in wash techniques.

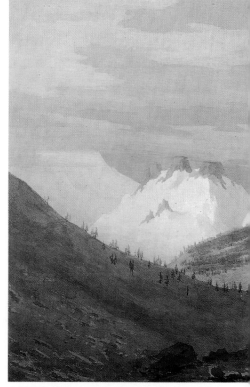

J.M.W. Turner RA, *Venice: Looking East from the Giudecca, Sunrise,* **1819**
This atmospheric study (left) is evoked with great economy of brushwork and color. The warm brown of the foreground creates a sense of distance across the lagoon.

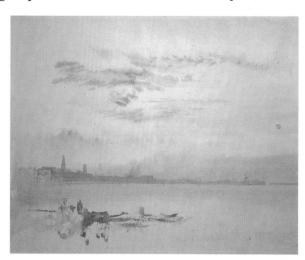

Thomas Girtin,
Bamburgh Castle,
Northumberland,
1797-99
This strong, fully
resolved landscape
is painted on warm
brown cartridge paper.
In order to highlight
certain details, Girtin
has used touches of
white bodycolor on
the cows and on the
gulls on the left, as
well as on areas of
the rock face.

Alexander Cozens *(c.1717-1786)* made a number of simple, economical studies from nature. His son J.R. Cozens *(1752-1797)* made landscapes characterized by their intensity and the power of the atmosphere they generate *(center)*. They have a breadth of scale in which tiny figures and buildings are dwarfed by huge mountains or vast city walls.

By contrast, but no less striking in their effect, are the paintings of Francis Towne *(1740-1816)*, whose almost diagrammatic style is immediately recognizable for its sense of form, design, and order.

For other contemporary artists such as Thomas Gainsborough *(1727-88)*, watercolor was primarily used to give color and tone to chalk drawings. His studies, with their loose, vigorous brushstrokes, demonstrate a remarkable spontaneity of approach.

A new status

Toward the end of the eighteenth century, two of the great talents of watercolor painting emerged, J.M.W. Turner *(1775-1851) (bottom left)* and Thomas Girtin *(1775-1802) (top right)*. The quality, breadth, and directness of their work would bring a new status to the medium. It allowed watercolor paintings to be seen as works of art in their own right rather than merely as colored drawings or studies for oil paintings.

Thomas Girtin began to stretch the watercolor medium further than it had gone before. He made paintings on rough cartridge papers in order to work on a more mid-toned ground. He pared down his palette and found he could create all the effects that he needed with just a limited range of colors.

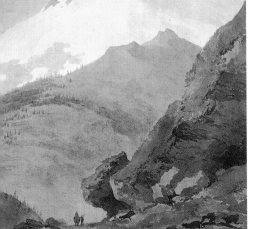

John Robert Cozens,
Chamonix and Martigny, c.1776
The figures dwarfed by the overhanging rock
and the apparent insignificance of the fir trees
convey the immensity of scale in this vast
mountain landscape.

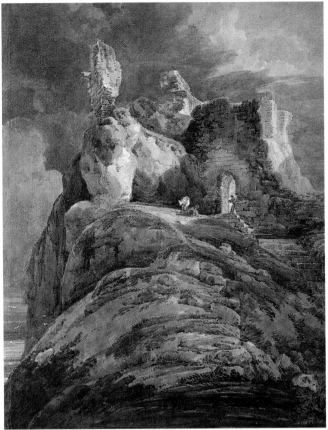

John Constable RA, *Landscape with*
Trees and a Distant Mansion, **1805**
This is a very relaxed study with the warm
yellow browns of the trees and hedges set
against the blues of the distant landscape and
the sky. Constable liked to make direct studies
from nature. The handling here is assured,
with large, generous brushwork.

9

Ahead of his time

It was J.M.W. Turner, however, who came to grips with watercolor painting as no artist had done before. Not content with mere coloring-in exercises, he constantly experimented with ways of moving the paint around and with new pigments and papers. He used color very directly, working wet-into-wet, scrubbing off, sponging, and scratching out (*see* pp.56-9).

There were many contemporaries of Turner, working both in England and in France, who made significant contributions to the art of watercolor painting. John Constable *(1776-1837)* made direct studies from the landscape in a vigorous and very immediate style, often using scraping and scratching out techniques to build up a textured effect. John Sell Cotman *(1782-1842)* produced unique paintings of a quite different order. These are carefully designed works in which flat planes of color and tone build like a jigsaw over the surface.

The landscapes of David Cox *(1783-1859)* are often turbulent or brooding in spirit. The speed of execution is visible in the large, rich brushstrokes dragged across the rough paper.

19th century developments

The mid- to late nineteenth century saw work in watercolor by a number of interesting artists in England, including Samuel Palmer *(1805-81)* *(right)* and Alfred William Hunt *(1830-96)*. In France, Camille Pissarro *(1830-1903)*, Paul Gauguin *(1848-1903),* and Paul Cézanne *(1839-1906)* were among the artists who used the medium. Cézanne painted more than 400 watercolors and experimented with transparent effects on white paper and denser bodycolor effects on toned paper.

The diversity of movements and styles in the development of painting in the twentieth century has been reflected in the great variety of approaches to watercolor.

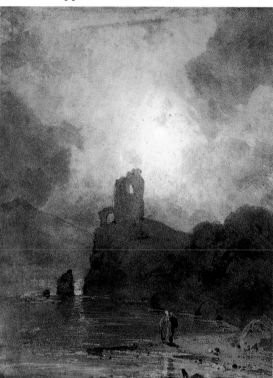

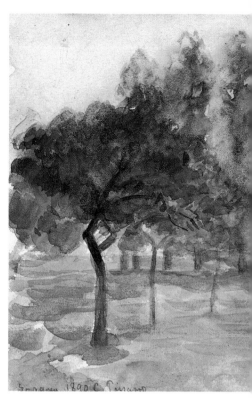

Camille Pissarro, *An Orchard, c.*1890
This delicate, watery study is one in which the colors are softly fused. But for all its delicacy and softness, it has great strength.

John Sell Cotman,
***Dolbadarn Castle, c.*1802**
Bathed in early evening light, this quiet atmospheric work displays Cotman's characteristic sense of order and design.

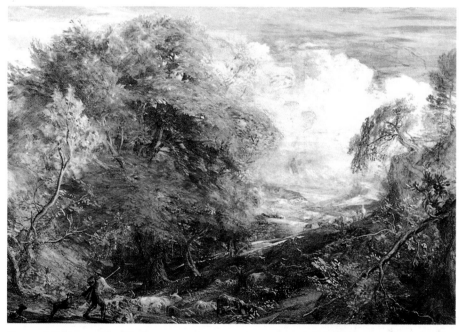

Samuel Palmer, *The Herdsman, c.*1855
Palmer's exuberant landscape is a celebration of nature, with its richly textured foliage and sense of sunlight. Using a variety of techniques, *Palmer has picked out the foreground highlights with white bodycolor, while in other areas he has scratched off the paint to get back to the white surface of the paper.*

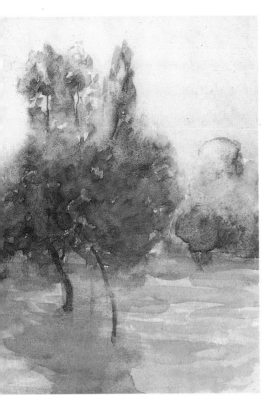

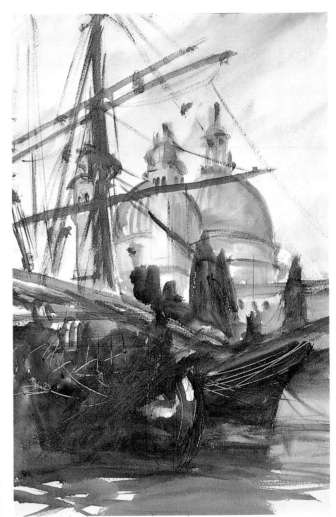

John Singer Sargent RA, *Santa Maria della Salute, Venice,* **1907-08**
This is a loose and busy study by an artist who made many fluent sketches in watercolor. Here Sargent has juxtaposed elements of both color and design as the angular masts and spars of the heavily toned boats cut sharply across the pale, rounded domes in the background.

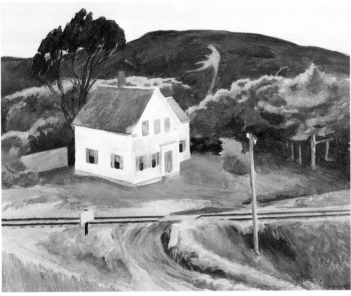

Edward Hopper, *Captain Kelly's House,* **1931**
This painting shows Hopper's characteristic honesty. Nothing is concealed, and yet it remains hauntingly enigmatic.

Among the many groups of artists who were influential in reshaping attitudes to the medium were members of a Munich group, which included Wassily Kandinsky *(1866-1944)*, Franz Marc *(1880-1916)*, August Macke *(1887-1914),* and Paul Klee *(1879-1940)* (*see* p.36). Kandinsky, born in Moscow, was one of the first to develop an abstract visual language, freeing watercolor from an overly pictorial truth and allowing images to float on the paper.

Klee made many experiments with the medium, working with thin, freely applied washes and also with densely pigmented gouache on a variety of surfaces. His works often have a magical, almost childlike, quality.

Across the Atlantic, artists such as Winslow Homer *(1836-1910)* and John Singer Sargent *(1856-1925) (top right)* were developing a distinctly American style. Sargent spent most of his life in Europe, adapting the skills he had learned as a portrait painter to a broad range of subjects. He echoed some of Homer's themes while becoming increasingly interested in the interplay of light and color.

Another American to become interested in the effects of light was Edward Hopper *(1882-1967) (left).* His watercolors can seem disarmingly straightforward, but they are highly charged, demanding a response from the viewer.

One of the most impressive watercolor artists of this century was the German Emil Nolde *(1867-1956)* (*see* p.22). He would take his paints with him to the theater, working by feel in the dark. Like Turner a century earlier, he pushed the medium to its limits, constantly experimenting with techniques and materials. His vast body of work was a celebration of color and of form that brought a new richness to the medium.

PAINTS

WATERCOLOR PAINTS ARE MADE by first mixing and then grinding powder pigments with a water-soluble binding material such as gum arabic. The pigments used to make watercolor paints are, in general, the same as those used in other types of paint, such as oils or acrylics. Gum arabic is a natural sap taken from the African acacia tree that gets its name from the species *Acacia arabica*. The type most commonly used nowadays is Kordofan gum arabic, which comes from the Sudan.

Early watercolor paint box

Rose Madder root

Pigments
Earth substances and animal substances form the basis of many pigments.

Terre Verte

Cochineal insects

THE GUM IS PREPARED in gum kettles as a 30 percent solution in water and subsequently mixed into a paste with the pigment. The paste is then ground on granite triple roll mills and, for tube colors, put into tubes, or, in the case of pan colors, dried off in large round cakes before being rammed through a die and extruded in strings. These are then cut to the whole- or half-pan size before being wrapped. Certain

additional materials can be added to the basic pigment/gum arabic mixture to create a stable product. These include glycerine, a syrupy liquid used in very small amounts to aid the adhesion and flexibility of the paint as well as keeping it moist. In the past, honey was often used for this

purpose. A wetting agent, such as oxgall, is used to help disperse the pigment particles. A thickener is often incorporated when the mix with gum arabic alone is too thin and requires more body. Dextrin is often used for this purpose and is occasionally used as a replacement for gum arabic when a particular pigment will not

How paint is made
The crushed pigment and gum arabic mix are left to dry as slabs of color (below) before being forced through a die and extruded as strips (below right). These are then cut into segments to form pan colors.

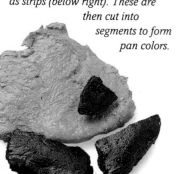

Slabs of dry color

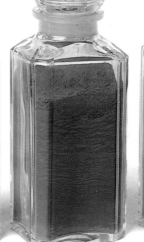

French Ultramarine

Viridian

Yellow Oxide

Cadmium Yellow

Lengths of pan color

Crushed pigments
Pigments are the solid separate particles in various colors that form the basis of watercolor paints. They each have certain characteristics, differing in their strengths, in their lightfastness, and in their degree of transparency.

flow out to a flat wash with gum arabic or reacts adversely with it. Dextrin is also used as a substitute for gum arabic in cheap watercolors. It is very resoluble, and this can affect the success of certain techniques, such as overpainting.

Raw Sienna

Artists' quality

Manufacturers also tend to add a preservative to prevent the growth of mold or bacteria. There is a great art to making the best-quality watercolor paints, since each pigment will require more or less of each of the ingredients in order for a stable and workable color to be made. With pan colors, the manufacturer has to ensure that the paint does not dry out in the box but, equally, that it does not absorb too much moisture and get soggy. The difference between artists' quality watercolor paints and the cheaper lines is marked. The pigment loading in the artists' paints is so high that it is the pigment that controls the behavior of the paint. The differences between pan and tube watercolors vary from pigment to pigment, but the main overall difference between the two is that there is more glycerine in the tube colors and this makes them a little more soluble than the pans.

The soft or moist watercolors used today are somewhat different than the early prototypes. J.M.W. Turner, for example, would have used blocks of straight pigment and gum mixes with no added moisturizer – what are now known as "hard" watercolors. Once Turner's washes had dried completely, they would have been

Tube and pan colors
Tube colors contain slightly more glycerine than do the pans, but not noticeably so. For large washes of color, tubes are the better option.

Gouache
Gouache or bodycolor is a watercolor paint that is characterized by its opacity.

easy to overpaint without disturbing the color underneath (subject to certain differences in particular pigments). Nowadays, if a color already on the painting is at fairly full strength, for example, one can find difficulty in overpainting it without redissolving it to some extent.

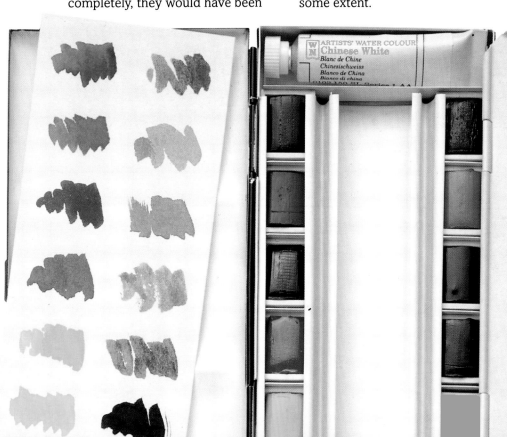

Paints and palettes
Saucers and paint box lids are just two of the many options for mixing paints. Painted color swatches can provide a useful point of reference.

COLOR MIXING

I**T IS THEORETICALLY POSSIBLE** to mix any color you want from just three colors – red, yellow, and blue – known as primary colors. In practice, however, it can be difficult to find pigments pure enough to do this, although a cool yellow, a crimson or bluish red, and a pure greenish blue will make good greens and good purples when mixed together.

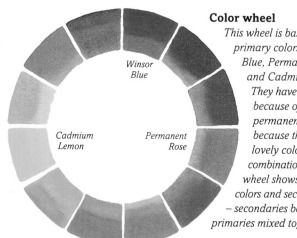

Color wheel
This wheel is based on the primary colors Winsor Blue, Permanent Rose, and Cadmium Lemon. They have been selected because of their permanence and because they make lovely colors in combination. The color wheel shows primary colors and secondary colors – secondaries being two primaries mixed together.

Winsor Blue

Cadmium Lemon

Permanent Rose

Secondary colors from Permanent Rose and Cadmium Lemon

Tertiary colors made from mixing all three primaries

O**F THE THREE PRIMARIES,** Permanent Red or Rose is a pure transparent color on the crimson side of red. It mixes very well with the other primaries to make violets or oranges. Cadmium Lemon is not as transparent as the red but, when reduced in washes, has a similar transparency on the paper.

Winsor Blue is a cool transparent blue with a high tinting strength, and its purity of color enables it to produce clean bright colors in mixtures. An alternative blue is French Ultramarine, which, like Winsor Blue, is very strong and can give deep-toned washes. It produces a lovely purple with Permanent Rose, but because it is a reddish blue, the greens it produces with yellow are grayish. Mixes made from two primaries are known as secondaries.

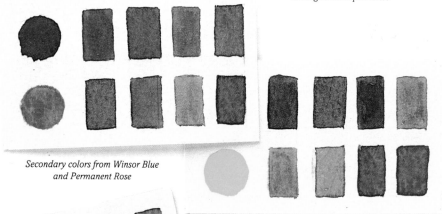

Secondary colors from Winsor Blue and Permanent Rose

Tertiary colors made from mxing all three primaries

Tertiary colors made from mxing all three primaries

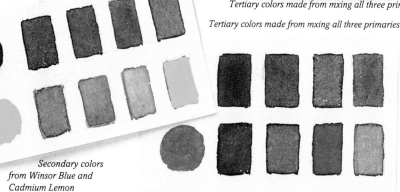

Secondary colors from Winsor Blue and Cadmium Lemon

PIGMENT QUALITIES

Pigments vary enormously in their particle size and weight. Manganese Blue is a heavy pigment and gives a very granulated wash, while the highly diluted lighter Winsor Green here has a streaky effect known as flotation.

Flotation

Granulation

There is no doubt that it is best to work, initially at least, with a limited palette (range of colors). On this page are a number of pigments that are all excellent and from which you might make your selection.

Reds and browns

Light Red and Venetian Red are warm orange-reds, and Indian Red is a lovely cool purplish red. Burnt Sienna is a transparent reddish brown, while Raw Umber tends toward a greeny yellow, and Burnt Umber more toward a dark reddish brown.

Light Red
Venetian Red
Indian Red
Cadmium Red
Permanent Rose
Alizarin Crimson
Rose Madder
Burnt Sienna
Yellow Ochre
Raw Sienna
Raw Umber
Burnt Umber

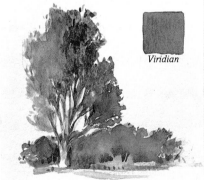

Terre Verte
Oxide of Chromium
Winsor Green
Viridian

Greens

Terre Verte and Oxide of Chromium are permanent, low-key greens, Terre Verte being a transparent pigment, and Oxide of Chromium being more opaque. Viridian is durable but is weaker than Winsor Green.

Cobalt Blue
Cerulean Blue
Winsor Blue
Cobalt Violet
French Ultramarine

Blues

There are many permanent blues, of which these are highly recommended.

Yellows

Yellow Ochre and Raw Sienna are useful earth pigments, as are the brighter and permanent Cadmiums.

Yellow Ochre
Raw Sienna
Lemon Yellow Hue
Cadmium Yellow
Winsor Yellow
Cadmium Orange
Cadmium Lemon

Recommended palette

Your own palette or choice of colors will evolve naturally as you try out new colors and different kinds of painting, but these are some good ones to buy in terms of purity of color, pigment strength, and lightfastness. They also tend to work well in combination.

Cadmium Red *has good lightfastness and a little color goes a long way.*

Permanent Rose *is a modern lightfast pigment which can replace the less durable Rose Madder.*

Cadmium Yellow *is bright and acceptably permanent and has a high tinting strength.*

Cadmium Lemon *is slightly paler than Cadmium Yellow and is equally permanent.*

Winsor Green *is both strong and permanent, mixing well with colors like Burnt Sienna.*

Winsor Blue *is also very permanent and has largely replaced the less lightfast Prussian Blue.*

French Ultramarine, *like Winsor Blue, is very strong and gives deep-toned washes.*

Burnt Sienna *is an earth pigment, so it is very durable. It has a lovely transparency.*

Raw Umber *is another very useful earth pigment that will not fade over time.*

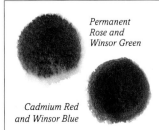

Permanent Rose and Winsor Green

Cadmium Red and Winsor Blue

MIXING GRAYS

There are a number of colors that make lovely grays in combination, as shown on the left. For a much darker gray, mix Winsor Blue with Burnt Sienna. Black should be used with caution in watercolors and is not needed to make gray.

MIXING PRIMARIES

I N WATERCOLOR TECHNIQUES, there are essentially two ways of mixing colors – you can mix them physically in your mixing tray, or you can mix them by laying one color on top of another on the paper. With the first method, you might add a small touch of blue to a yellow wash in your tray to create the color green. With the second method, you can paint a yellow wash onto your paper, let it dry, and subsequently overpaint a pale blue wash to arrive at a green. Whichever painting method you use, the effect is essentially the same, although overlaying a wash of a second color, if it is done well, can create a greater richness of hue. This is because your eyes should still be able to perceive the first color reflected up through the subsequent wash.

Orange
Two ways of arriving at a color: left, laying one wash of color over another; right, mixing colors in a tray before painting.

BOTH OF THESE FRUIT still lifes are painted by physically mixing three primary colors in a mixing tray before they are applied to the paper. The difference between the two versions is that the top one is painted with rather strong colors – what are known as high-key colors – while the bottom one is painted with muted, or low-key, colors.

Mixing colors
The mixing of two primary colors produces secondary colors, and the mixing of all three primary colors produces tertiary colors. Notice the range of colors that have been produced in each case with just three colors.

Range of colors produced from high-key primaries

High-key primaries
All the colors in this still life are created by mixing just three high-key primaries: Permanent Rose, Winsor Blue, and Cadmium Lemon. These colors produce a vast range of lovely hues; the swatches here are just a selection.

Range of colors produced from low-key primaries

Low-key primaries
This low-key study relies for its effects on mixing Indian Red, Cobalt Blue, and Lemon Yellow Hue. These more muted versions of the three primaries work well in combination, producing subtle ranges of reds, oranges, greens, and grays. The white highlights are created by the actual paper surface, rather than by an application of color.

Overlaying color

Here the tulips have been painted using three primaries, but the visual effects are created by overlaying washes of pure color, rather than by physically mixing the paint before applying it. Whichever way you choose to work, it is a good idea to do color swatches on a scrap of similar paper in order to try out each color on its own, as well as to see the effect when one color is overlaid onto another, dried color.

1 ◄ Starting with a pencil outline of the tulips, mix up a wash of Cadmium Lemon, and begin applying it to the drawing with a small round brush. Paint in most of the leaves, the stem, and the flowers, but be sure to omit any highlighted areas that you want to appear white in the final image.

Cadmium Lemon

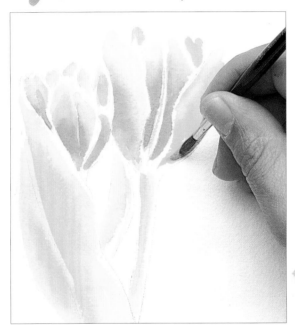

2 ◄ Allowing the yellow wash to dry, mix up a wash of Permanent Rose and test it on a dried swatch of the yellow to make sure that it produces the right kind of red. Now overlay your rose wash on the body of the petals.

Permanent Rose

The darkest areas of the petals have touches of Winsor Blue over the other two colors.

The nature of overlaid color is clearly visible in the stem and the leaves.

The blue wash is stronger and denser in certain areas. This creates the shadows and gives the flower its three-dimensional form.

Ceramic palette

3 ◄ Again, allowing the paint to dry between layers, mix up some Winsor Blue and test it on a swatch of dried yellow. Using the tip of the brush, apply it to the darker areas of the stem and the leaves. Notice how the blue over the yellow creates an effective leaflike green, even though no green has been applied.

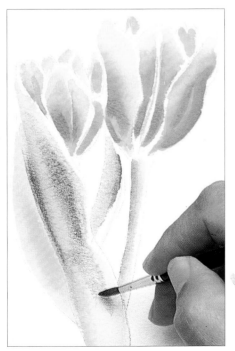

Winsor Blue

COLOR HARMONY

CONSIDER THE BALANCE OF COLORS in a painting. Are the colors bright, and do they seem to shout at you, or are they low-key and more subtle in their effect? If you are creating your own still life, you have the advantage of being able to select particular items and arrange them in a variety of ways until you are happy with the result. You can manipulate not just what goes into the painting, in terms of shapes and textures, but exactly where everything goes. You can play with the composition to make it crowded or sparse, vibrant or muted. You can create a subtle balance in the range of colors or go more for primaries and secondaries. But whatever arrangement you choose, whether it is dark or light, high-key and rich in color, or low-key and subdued, you will find yourself instinctively striving for a sense of balance.

High-key and low-key
The contrast in colors between the vibrant, manufactured objects of the beach ball and towels and the subdued, balanced tones of the pebbles and shells is striking. Here high-key and low-key are combined, the vibrancy of the stronger hues offsetting nature's more subtle offerings.

You can create interesting compositions by introducing bold primary colors into your still life.

Colors along the beach are generally low-key – soft muted creams, yellows, and browns.

IN JUGGLING THE ELEMENTS of sand, shells, and towels, you are making decisions about shapes, textures, and colors. Nature abounds with color, although along the seashore the colors are often muted, as pebbles, shells, driftwood, and sand provide a range of pale yellows and browns. But there are complementaries too – opposites on the color wheel – so that the yellows are balanced by the purples of the seaweed, as well as harmonious colors in which the tones or hues of color are similar and work well together.

Afterimages
If we look at an area of strong color for a long time and then look away at an area of white, we should perceive the complementary of the first color. So if we stare at an area of red and then look at a white wall we should, just for a moment, see a green shape. Similarly, if we focus on an orange-red color first and then look at a bright yellow, we might see the yellow as green because we are carrying the blue afterimage of the orange-red. These are the kinds of color effects that we should bear in mind when planning a painting.

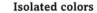

Low-key colors
Here shells, pebbles, and starfish form a harmonious, low-key still life against the sand. The tones of the individual elements are roughly the same, with no single item vying for our attention.

Adjacent colors

Although technically the term adjacent color means one that is next to another on the color wheel, it is more commonly used to mean simply any color that is next to another as, for example, in a painting. Every color we use affects the appearance of the color next to it. We can take advantage of this by painting with complementaries as adjacent colors. The colors will then appear brighter and will irradiate against each other.

For example, putting orange/red next to violet makes it appear more orange because the violet induces its complementary yellow. The same orange/red placed next to orange will look more blue because the orange induces its complementary blue. Many modern watercolor painters have used the technique of isolating colors from each other by leaving a white or gray gap between the touches of pure color. This allows the individual colors to retain their clarity of hue.

Adjacent colors
The beach ball, with its vibrant primary and secondary colors, is offset by the equally strong towels. Note how the red of the ball reacts against its complementary green in the towel.

Isolated colors
The device of leaving unpainted edges around areas of bold color serves to heighten the intensity of the individual colors.

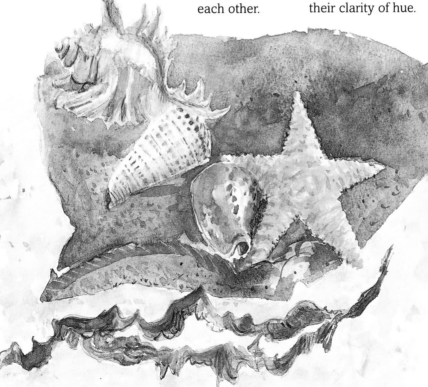

Complementary colors
This composition is made up of complementary colors – yellows and purples, with the shells highlighted against the purple towel. Opposite each other on the color wheel, complementary colors are mutually enhancing, with each one of a pair intensifying the effect of the other.

LIGHT AND COLOR

Warm
lights /
cool shadows

ONE OF THE MOST IMPORTANT aspects of watercolor painting is the way in which everything that we look at is affected by light, whether it be sunlight, moonlight, or artificial light. It can be tempting to paint something a certain color because that is the color we know it to be, for example, the pale yellow of sand on a beach. But at noon the sun can be so strong that the sand is virtually white, whereas in the late afternoon the sun may cast long, purplish shadows. You need to look carefully at the scene before you consider the color temperature of the light and how this affects the appearance of the ground onto which the shadows fall. A useful principle to follow is "warm lights/cool shadows," and conversely "cool lights/warm shadows." This principle holds whatever the subject and however subtle the effects.

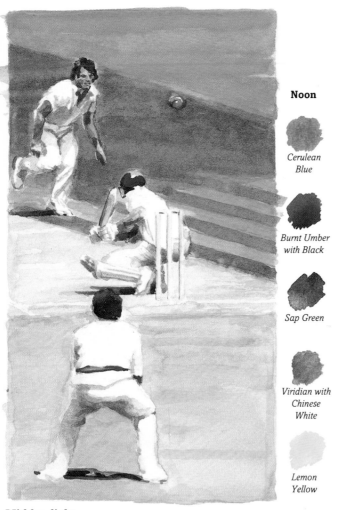

Noon

Cerulean Blue

Burnt Umber with Black

Sap Green

Viridian with Chinese White

Lemon Yellow

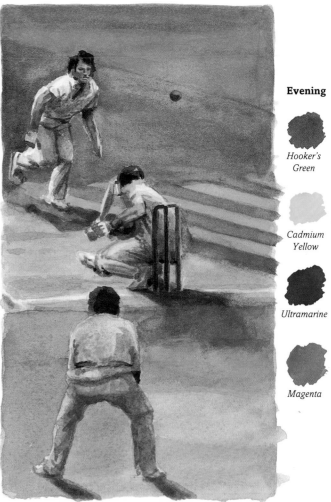

Evening

Hooker's Green

Cadmium Yellow

Ultramarine

Magenta

Midday light
At noon, when the sun is bright in a cloudless sky, we see lights and darks and very little in between. In the brightly lit areas, the color is washed out by the hard, cool light, and the shadows are too dark to contain much color. If, instead, the light from the sun is partially diffused by clouds, the shadows will be less pronounced and the colors will be more evident.

Evening light
In the evening, when the sun is closer to the horizon and the light is less intense, the land can be bathed in a rich golden light. Here, a wash of Cadmium Yellow and Hooker's Green transforms the color of the grass, while Magenta and Ultramarine give the bluish/purplish tinge to the cricketers' white clothing.

Not only does light affect the colors that we see, but it gives form and life to shapes that might otherwise seem dull and flat. Objects in the foreground will be brighter and have more color than those farther back, so in a case where you can see a panorama of tree-covered hills, the trees in the foreground will appear much brighter and more vibrant than those near the horizon. In terms of both what you see and how you paint it, a general guideline is that so-called warm colors advance toward you and cool colors recede. You can test this when you paint by adding warm colors (such as orange/red) and cool colors (such as blue) and seeing which elements appear to advance and which appear to recede.

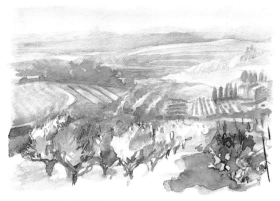

Monochromatic study
When you look at a landscape, you will notice how the quality of light changes noticeably from the foreground to the background, markedly affecting all the colors that you perceive. By starting with a tonal study of the scene, you can see quite clearly how the tones in the foreground are brighter and stronger than those in the background.

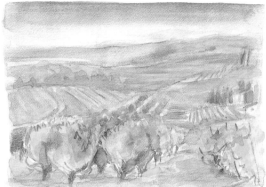

Chromatic study
In order to manipulate the way certain areas advance and recede in your painting, add warm colors such as yellows or reds to the foreground and cool colors to the background. Here you can see how the yellows have made the foreground trees stand out, while the cool, bluish purples, that have been added to the distant hills, make them appear even farther away.

Tinted acetate

Adjusting the color
Painting in watercolors allows you to adjust the overall color of your painting by laying a wash over it. For example, you can make a painting warmer by overlaying a pale yellow wash over it, or cooler by overlaying a pale blue wash. Here, sheets of tinted acetate have been used to demonstrate the visual effects of overlaying warm and cool washes of color. You will find that, depending on the time of day, the weather, and the season when you are painting, you will need to adjust the intensity of the colors you use and the degree to which they seem warm or cool.

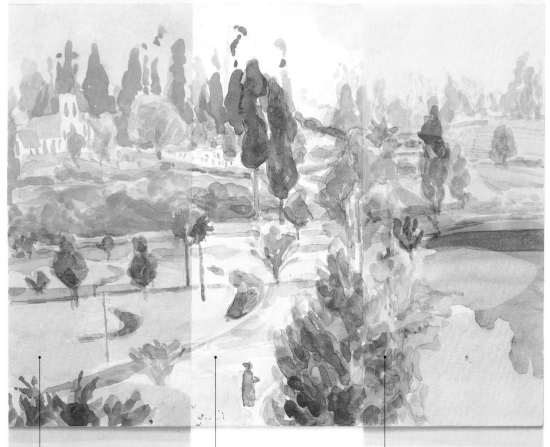

Although the painting is of a tropical landscape, the blue acetate makes the countryside seem almost English.

The central panel shows the actual painting, without any color adjustments.

The pale yellow acetate has the effect of bathing the scene in a wash of golden sunlight.

GALLERY OF COLOR

Watercolor is a highly appropriate medium for exploring the effects of color, as the pure colors of the pigments are seen in transparent washes against the white of the paper. Even when colors are overlaid, the translucent nature of the medium allows a subtle layering of color. But equally, striking color effects can be achieved by combining either high-key or low-key colors within a painting.

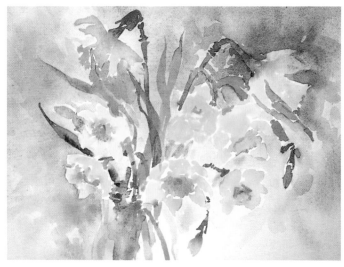

Sue Sareen, *Daffodils*
Sareen favors a limited palette. This painting shows the effects that can be achieved with just a blue, a yellow, and an ochre. Here she has worked with a very wet brush, allowing the background colors to merge while using the white of the paper to pick out the form of the flowers.

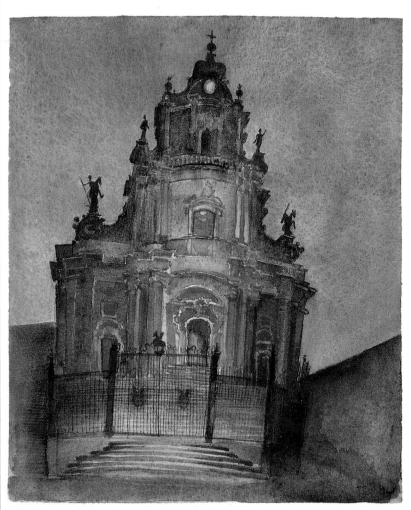

Philip O'Reilly, *San Giorgio at Dusk*
Painted as dusk set in, this striking image relies for its effect on the contrast between the dark solidity of the building against the intense blue of the evening sky. O'Reilly has used cream-colored paper to emphasize the warm hues of the Sicilian stonework and a granular blue-purple pigment to add texture and depth to the sky.

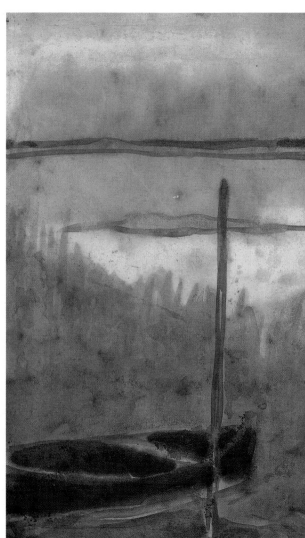

Paula Velarde, *Dining Room Brantwood*
Using candle wax to give a sense of texture, Velarde has overlaid bold washes of pigment with drier applications of color, capturing the drama of the setting by counterpointing the blue with threads of an equally strong yellow. The hints of red in this predominantly blue scene serve to balance the overall effect.

The eye is drawn back and forth from the interior scene to the view from the window, with the bright red sailboat forming a point of interest in the lake.

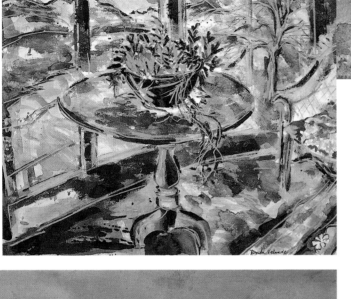

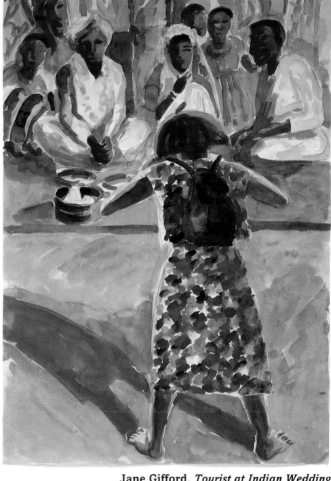

Jane Gifford, *Tourist at Indian Wedding*
In this high-key study, the traveler paints a view of herself as she photographs the bride and groom at a wedding. Choosing a range of fluorescent colors to capture the heat and feel of her surroundings, Gifford emphasizes the strength of the sunlight by painting yellow highlights around herself and on the clothes of the wedding party.

Emil Nolde (attr.), *Ruttebüll Tief* **(c.1916-20)**
Here Nolde displays his characteristic celebration of color, reveling in the power and purity of certain pigments. He has used washes of intense hue to create a highly personal non-naturalistic landscape. This vibrant painting demonstrates high-key color at its most dynamic, with a perfect balance between adjacent and complementary colors and between the warmth of the central middle distance area and the unexpected and yet perfectly controlled coolness of the foreground.

BRUSHES

THERE ARE TWO MAIN TYPES OF BRUSH: those with soft hairs, including red sable, ox hair, squirrel, and polyester brushes, and those with harder hairs, the bristle brushes. Soft hair and synthetic brushes are the more traditional in watercolor painting techniques, but bristle brushes are good for mixing up large amounts of color and also in scrubbing out exercises.

Earthenware vase for displaying brushes

THE ROUND SOFT HAIR BRUSHES, and in particular the sables, have been used to great effect in watercolor painting. They have excellent paint-carrying capacity, and they are springy and resilient. They come to a good point and can be used for fine work and also for laying in broader washes. Red sable is the tail hair of the Kolinsky, a species of mink. The soft wooly hairs are removed, and only the strong, "guard" hairs are used to make

brushes. If you were to look at an individual hair through a microscope, you would see that, far from being smooth, it has a varying structure from root to tip, which allows it to retain the paint. Each hair has a "belly" – a wider section in the middle – and consequently it tapers above and below. The belly forms spaces in the brush that act as reservoirs for the paint.

The hairs are of varying lengths between 1 – 2½ in (25 – 60 mm). The long hairs are the rarest and the most prized and are around four times as expensive as the shorter ones.

The manufacturing process is all done by hand. The hair, which has previously been steamed under pressure and straightened, is put into a cannon, tapped, and combed out to remove short hairs.

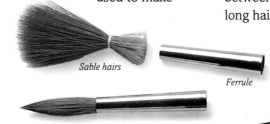

Sable hairs

Ferrule

Sable brush

Anatomy of a brush
Brushes are made by hand; the lengths and quantity of the hairs are judged by eye.

The blunt "white" hairs are removed and the correct quantity taken to make an individual brush. The amount is judged by eye as just enough to fit snugly into the ferrule – the metal tube connecting the hair and the handle.

Made by hand
In the smaller sizes, the hair comes to a point naturally. In the larger sables, the hair has to be turned or twisted to form the shape of the brush. It is then tied with a clove hitch knot, trimmed, and cemented into the ferrule with epoxy resin for the larger sizes and shellac for the smaller sizes. The sable brushes are dipped into a weak gum arabic solution and individually sucked, so that they come to a point.

CARE OF YOUR BRUSH

- It is good practice always to paint with two jars of water, one for rinsing the dirty brush and the second for rinsing it again before mixing a new color. This way you will keep your brush and your colors clean. When you finish painting, wash your brushes with soap to remove all traces of paint and then rinse them thoroughly. Do not use hot water for this, as it may expand the ferrule, soften the glue, and make the hairs fall out.

- Brushes must be perfectly dry before being put away to avoid the possibility of mildew.

- You should keep your brushes clean and avoid building up deposits of paint at the ferrule, as this has the effect of splaying the brush open and ruining the point.

- You can judge a round soft-hair brush by its tip. A good one will always come to a point when dampened.

The toe (tip) of the brush

The heel of the brush

The synthetic soft-hair brushes are generally made from polyester monofilaments, which, unlike the sable hairs, do not have a scale structure or surface irregularities. They tend to suck up the paint and also release it more quickly than the sables would. Generally, however, they are fine substitutes for sables. Manufacturers also produce brushes that combine natural and synthetic fibers in sable/polyester ranges. While they do not have the characteristic springiness of the pure sable, they still do a perfectly reasonable job.

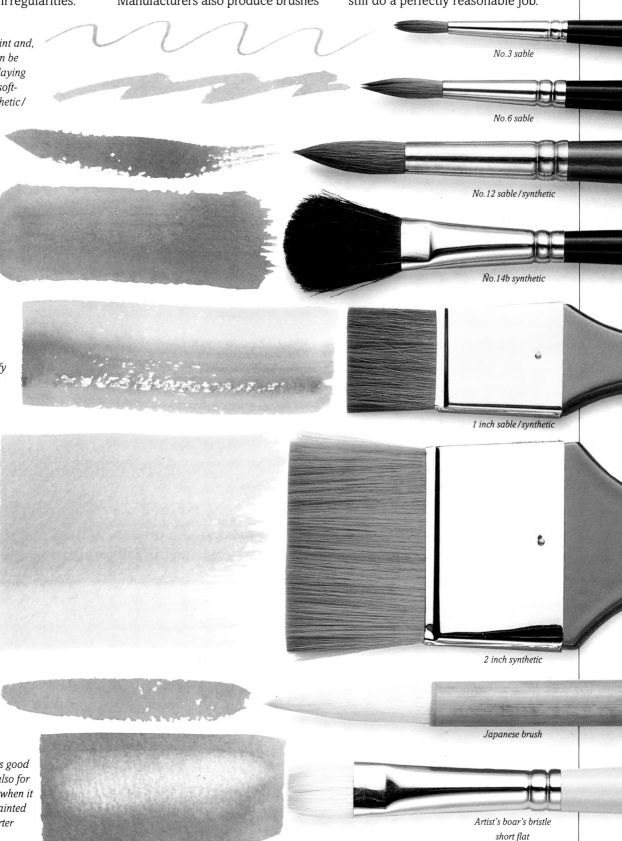

Round brushes
These come to a good point and, depending on the size, can be used for fine work or for laying in washes. The synthetic soft-hair brushes and the synthetic/ sable blends are fine for most manipulations, although they are less springy than the sables.

No.3 sable

No.6 sable

No.12 sable/synthetic

Wash brush
This moplike wash brush is useful for laying down broad strokes of color over large areas.

No.14b synthetic

Flat wash brush
The flat one-stroke brush is good for toning paper or for laying a wash. It can also be used to modify a wash that has just been laid down.

1 inch sable/synthetic

Large wash brush
Useful for laying down very broad strokes of color, this extra-wide wash brush comes into its own when covering large expanses of paper. The synthetic fibers have good paint-holding qualities and are excellent for laying washes and controlling the flow of paint.

2 inch synthetic

Bamboo brush
Oriental soft-hair brushes are made of deer, goat, rabbit, or wolf hairs.

Japanese brush

Bristle brush
This boar's bristle brush is good for mixing up color and also for scrubbing out techniques when it can be worked into the painted area with water. The shorter bristles aid control.

Artist's boar's bristle short flat

BRUSHMARKS

BRUSHES CAN BE USED in a number of ways, depending on the style or approach adopted by the artist. They can be used vigorously and expressively, for instance, to create brushstrokes of great energy and immediacy, or they can be used simply as the invisible tool that allows a wash to be applied evenly within a prescribed area. Between the two lies a world of different approaches. Factors that come into play are the amount of paint in the brush, the speed of the stroke, the angle of the brush, and the type of brush being used. The nature of the paper will also play a part. These pages show the variety of brushstrokes that can be made using just one brush.

Brushmarks from a single brush
All the strokes on these pages are made with a No.9 sable.

With a well-loaded brush, gradually increase the pressure until the full width of the brush comes into play.

Using lumps of pan paint, apply them to the paper with a very wet brush.

Using the tip of the brush in a circular motion, gradually increase the pressure to use more and more of the brush hairs.

A thin line can be drawn by just using the tip of the brush.

Rotate the side of the brush in a circular motion.

Roll a fully loaded brush on its side in complete revolutions.

Sponge the paper first, and then press the brush down firmly onto the dampened surface.

The tip of the brush can draw fine dots and outlines.

THIS SIMPLE PAINTING puts into practice some of the strokes that can be made with a single brush, again using a No. 9 sable. It is all a matter of control and of getting to know the nature of the brush, the paint, and the paper.

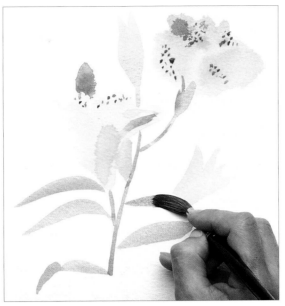

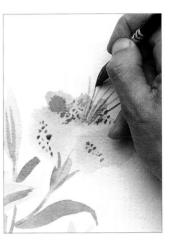

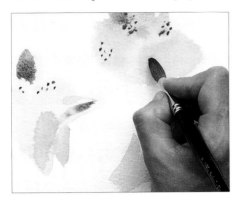

1 ▲ Wash in broad petal shapes with the body of the brush using Rose Madder and a touch of Ultramarine. Then, with a stronger mix, use the tip of the brush to dot in color. Where the petals are still wet, the dots will bleed.

2 ▲ Draw the stem in a thin line, using a mix of Rose Madder, Ultramarine, Sap Green, Viridian, Yellow Ochre, and Winsor Blue. Then, pressing harder on the brush, complete each leaf with a single brushstroke.

3 ▲ Using the finest point of the brush, draw in the filaments using Sap Green. If you are worried about being unable to control these fine lines, do a few practice lines on a rough scrap of paper before you begin, keeping your hand as steady as possible.

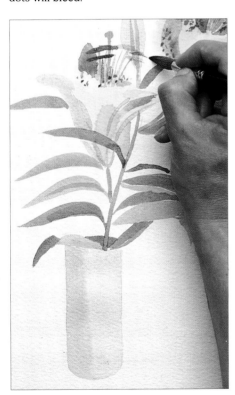

4 ▲ The anthers at the end of the filaments are Indian Red painted in dry brushstrokes. Applying the paint onto dry paper in this distinctive way creates a sense of depth and texture.

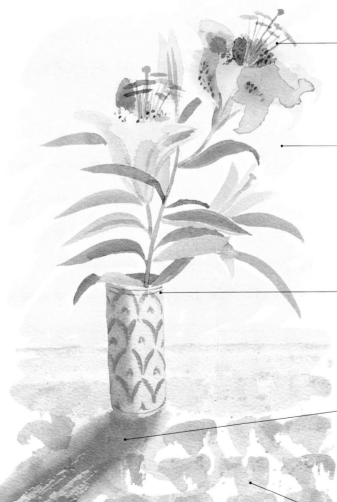

For fine lines just the tip of the brush comes into play.

To create a sense of depth, the background is painted in with a very dilute Yellow Ochre applied in broad brushstrokes.

You can make lines as fine as these with a No.9 brush by having just a touch of paint on the longest hairs.

The shadow from the vase is created by using the full body of the hairs to apply the paint both wet and dry.

The patterned surface is achieved by dipping the brush into a thick mixture of Winsor Blue and Ultramarine and then rolling the brush repeatedly on its side.

OTHER MARKS

ALTHOUGH PAINT BRUSHES are the tools that are traditionally used for applying paint and are essential for a vast range of techniques, there are nevertheless many alternative methods for applying watercolor paint onto your paper.

It is largely a matter of trying out different implements and seeing which you prefer and which get closest to the effects you are after. But you do not have to buy lots of expensive equipment – there are any number of ordinary household items that you can experiment with. Artists have used such diverse materials as pieces of cardboard, sponges, wallpaper brushes, combs, paint rollers, and even squeegees, in order to achieve interesting effects. You will need to try different dilutions of paint and various types of paper to achieve the best results.

This bamboo brush, with its mix of animal hairs, creates broad, loose brushstrokes.

Blotting paper is used here. First apply paint with a brush. Then dip an edge of torn blotting paper into wet paint, and press it down. Draw the blotting paper along to create the pattern.

Dip an old sponge in masking fluid, press it onto the paper and let it dry. Paint over it and, while the paint is still wet, lift it off with a tissue.

Dip one edge of the cardboard in some paint and drag it in vertical or horizontal strokes.

Cardboard
The gate has been painted with cardboard, while the grassy effects are the result of sponging.

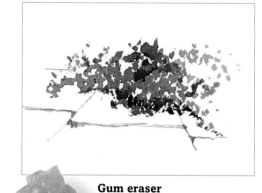

Gum eraser
Gradually build up a ball of gum. It will have a mottled, uneven texture. Dip it into some paint and press it onto your paper. Repeat the process with other colors.

Old brushes have their uses. Here a worn, splayed brush has been dipped into a pale blue-gray wash and used to paint this tree.

This tree is painted with a fine sable brush. There is more control, particularly in the trunk, than can be achieved with the splayed brush.

The rigger, with its characteristic long, fine hairs, is capable of perfectly controlled lines and so is good for more detailed work.

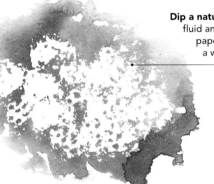

Dip a natural sponge in masking fluid and apply it lightly to the paper. After it has dried, paint a wash of violet over it.

Use a comb for this effect. First paint the two colors in turn and, while each is still wet, draw the comb across the paint to create the blades of grass.

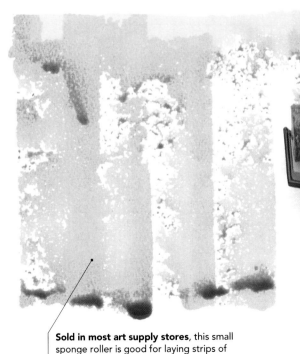

Sold in most art supply stores, this small sponge roller is good for laying strips of color. The tone will vary depending on how much paint the sponge has absorbed and on how hard you press down on it.

Natural sponge

The leaves are painted by dipping a sponge in light green and then dark green, and pressing it down on the paper. The irregular surface of the sponge creates interesting textures. For the trunk, dip the sponge in brown, squeeze it, and draw it down the page.

GALLERY OF BRUSHSTROKES

ONE OF THE PLEASURES of watercolor painting is that you really only need a couple of good-quality brushes to get started – a small round pointed sable for detailed work and a bigger, soft-hair round brush for washes and larger effects. Sables, with their characteristic springiness, are the traditional watercolor brush, but there are any number of excellent alternatives to choose from, including synthetic hair brushes and synthetic/sable mixes.

Julian Gregg, *Dieppe Harbor, Summer*
This study comprises a series of solid brushstrokes corresponding to areas of buildings in shadow and their reflections. Here the simple fluent line drawing was the essential starting point for the straightforward and economical brushstrokes. Gregg relied on just one or two brushes and a limited palette of colors, allowing the brushstrokes to remain clearly visible in the finished work. He built up the work swiftly and confidently, starting with the light areas and ending with the darkest reflections in the water.

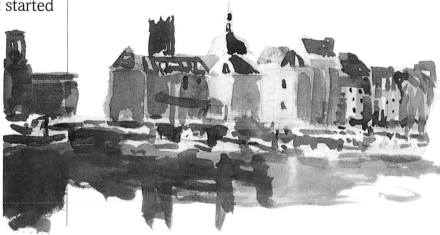

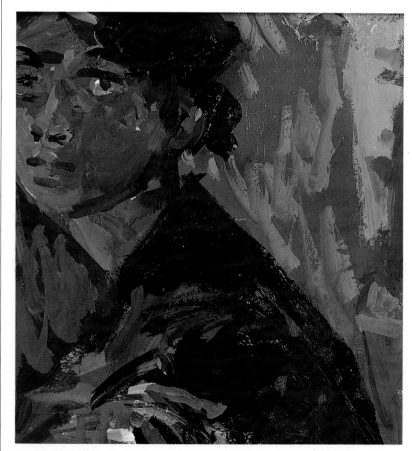

Ian Cook, *Head of a Girl*
The intense color of the highly pigmented gouache shows in the thicker, dense brushstrokes, especially in the face and neck. The brushwork here is closer in feel to that of an oil painting with its rich, impasto effect.

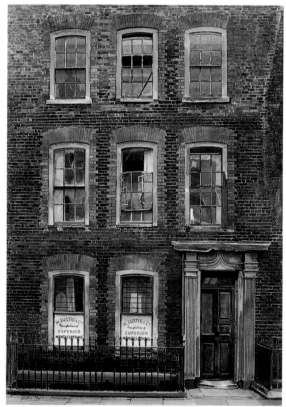

John Pike, *Number 10 Fournier Street*
The artist worked from photos, sketches, and color notes to arrive at this degree of realism. The brushwork is relatively invisible so that nothing detracts from the final image. Pike built up the painting gradually, starting with overall washes and then filling in the details with a fine brush.

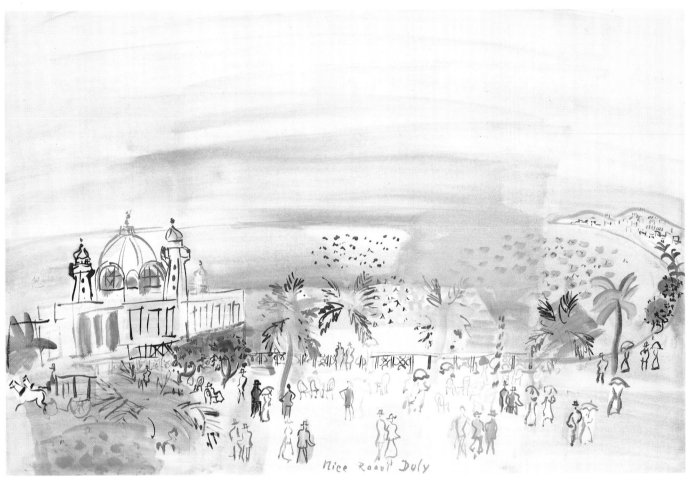

Raoul Dufy, *Nice, Le Casino*, 1936
This lovely loose study perfectly illustrates the artist's control over brushwork, with the figures, trees, and outlines of the building fluently touched in with the toe of a pointed, soft-hair brush.

These rapid and assured touches, balanced by the broader brushstrokes of some of the palm trees, are painted over sweeping washes of pinks, lilacs, and blues. The outlines of the buildings are similarly drawn in a wide range of colors.

Gisela Van Oepen,
The Sun Sets Behind the Tree
Painted with confidence, the brushstrokes here are clearly visible, from the diagonal sweeps of the sky to the large frilly strokes used for the branches.

The bright rectangle in the lower left-hand corner of the window is light coming through from the far side of the building. Using a fine pointed brush, Pike painted carefully around this area, so that it is actually the paper, rather than any paint, that creates this bold shaft of light.

31

PAPER

WATERCOLOR ARTISTS REQUIRE paper in varying weights, of a quality that will not yellow with age, and with a range of surface types from smooth to rough. The paper should not buckle once it has been stretched and needs to be sufficiently strong to withstand rather severe treatment. Additionally, it should have the right degree of absorbency for the kind of painting the artist has in mind.

Oriental sketchbooks
Unusual papers provide interesting textured surfaces.

PAPER IS PRODUCED by the felting together of cellulose fibers, obtained from a variety of plant sources. In the West, most artists' papers are now produced from cotton fibers, while Oriental papers are made from a great variety of plant sources. These have fibers of varying length and strength, which impart very different characteristics to each type of paper.

The first stage of manufacturing is the pulping stage, during which the material providing the fibers is blended with water to produce a slurry. This is beaten

Cylinder mold machine
Here the pulped fibers are drawn over a wire mesh, arranging themselves in a random order.

and refined in order to produce fibers of the requisite quality. A neutral internal sizing is then added to the pulp. This, together with the additional surface sizing that may be added later, controls the absorbency of the paper.

Today, most watercolor papers are not made by hand but on a cylinder mold machine. From here the paper passes through a press on a woolen felt or blanket, which gives it a rough or a fine grain surface, depending on the weave used for the felt. The paper is still very wet, so it is passed

Waterford Rough

Waterford NOT

Waterford Smooth

Winsor & Newton Smooth

Mold-made paper
These are all standard machine-made watercolor papers. Note how the different surfaces affect the appearance of the paint, the blue looking much darker on the toned paper and much grainier on the Rough sheet at the back.

Winsor & Newton NOT

Bockingford White NOT

Bockingford Gray NOT

Bockingford Oatmeal NOT

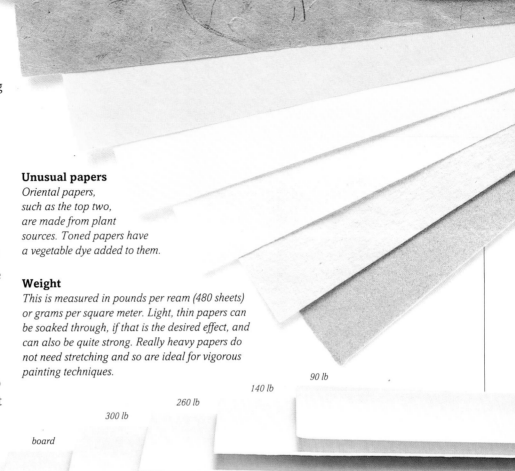

through a press, and then around drying cylinders to remove the excess water. The paper is subsequently immersed in warm gelatin for surface sizing before being passed through squeeze rollers and dried. The function of the gelatin sizing is to decrease the paper's absorbency and make it harder. It allows it to withstand severe treatment such as constant repainting and scrubbing off.

Absorbency

This is determined by the amount of sizing used in the manufacture of the paper. (You can quite easily add a coat of gelatin sizing to make your paper harder and less absorbent.) A paper with no sizing is known as "Waterleaf". Many of the Oriental papers are very absorbent, taking up the brushstroke as it is made and not allowing any further manipulation.

Acidity is another factor you should consider. It is always preferable to use acid-free paper with a neutral pH. This ensures that the paper will not darken excessively with age.

Unusual papers
Oriental papers, such as the top two, are made from plant sources. Toned papers have a vegetable dye added to them.

Weight
This is measured in pounds per ream (480 sheets) or grams per square meter. Light, thin papers can be soaked through, if that is the desired effect, and can also be quite strong. Really heavy papers do not need stretching and so are ideal for vigorous painting techniques.

90 lb

140 lb

260 lb

300 lb

board

Blocks and pads
Watercolor paper can be bought in loose sheets, in spiral-bound pads, and in blocks. The blocks, which are bound on all four sides, have an advantage in that the paper does not need to be stretched before painting.

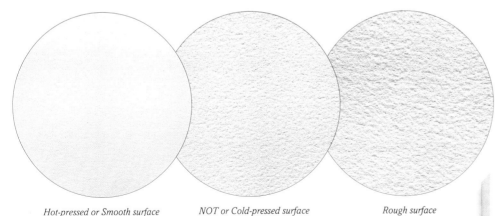

Hot-pressed or Smooth surface

NOT or Cold-pressed surface

Rough surface

Surface and weight

The three standard grades of surface in Western papers are Rough, HP (Hot-pressed) and NOT (Cold-pressed). Rough is just as its name suggests, a rough surface. Hot-pressed comes out very smooth, and NOT or Cold-pressed is a fine-grain or semi-rough surface – literally "not hot pressed". These categories vary enormously from one manufacturer to another, so look at several types before deciding which to buy. In terms of weight, both light and heavy papers have their advantages; it is largely a question of what you want to paint and which particular techniques you plan to use.

STRETCHING AND TONING

WATERCOLOR PAPER has to be stretched in advance to ensure that it does not pucker and buckle when you are painting on it but stays firm and flat on the drawing board. The procedure is quite simple: all you need is

Unstretched paper

a board, masking tape, a sponge, and water. Once your paper has been stretched, you may want to tone it. Although you can buy toned paper, toning it yourself creates a somewhat different effect, since you are in fact laying a transparent color over white paper. Also, it allows you to create any color you desire.

Stretching paper

Unless you are going to use blocks of watercolor paper or very heavy paper, you should always stretch your paper before you start painting. You need to find a board that is about two inches wider than your paper on all four sides. It should be thick enough to withstand the tensions of the stretched paper without bending, and it should be slightly absorbent. Plywood, chipboard, particle board, or medium, density fiberboard make good surfaces and can be purchased cheaply from any lumber yard.

Materials for stretching

Sponges

Gum tape

Fiberboard
Chipboard
Plywood

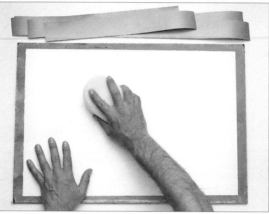

1 ▲ Start by preparing four strips of heavy-duty masking tape of the right length, one for each side of the paper, and put them to one side. Next, wet your sheet of paper thoroughly with cold water to allow the fibers to expand. Don't use hot water, as this might remove the gelatin surface sizing of the paper.

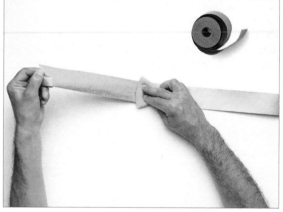

2 ▲ Make sure the whole sheet is uniformly damp. You can wet the paper with a sponge or immerse it in a bath of cold water for a few minutes, depending on the thickness of the paper. Once the paper has expanded, moisten your lengths of gum tape with a sponge. If they are too wet, they will not stick properly.

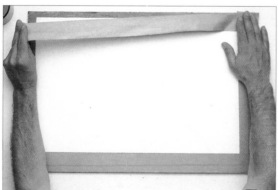

3 ▲ When your paper is thoroughly wetted, put it on the drawing board, smooth it out, and sponge off any excess water. Next, take the gum tape and stick the paper down firmly around the edges.

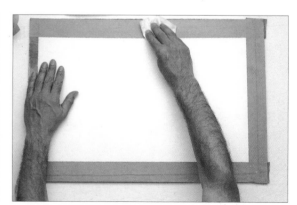

4 ▲ Now let the paper dry. You can speed up the process using a hair dryer on a low setting if you wish. When the water evaporates, the paper fibers contract, and the paper becomes hard and flat.

Toning paper

Most watercolor paper is white. While this suits those techniques that rely on the brightness of the ground to reflect light back through the color, the history of watercolor painting is full of works created on paper of widely varying tones. There are several advantages to toning paper yourself – it allows you to experiment with a wide range of different-colored grounds for your painting. Also, simple studies will look quite finished, with the color of the paper serving to unify the whole. One difficulty, however, is the problem of re-solubility – if you tone your paper with watercolor paint, you risk dislodging the color when you paint on it. Using well-diluted acrylic paints for toning will eliminate this risk.

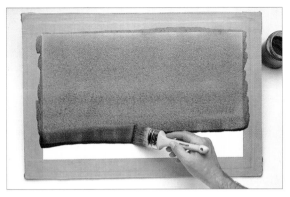

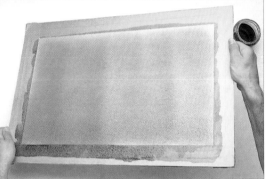

Materials for toning

Acrylic paint

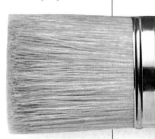

1½ inch wash brush

1 ▲ Mix up sufficient paint – in this case well-diluted acrylics – to cover the whole sheet. Apply the mix using a large brush with the board at a slight angle to the horizontal. Pick up any drips with each successive brushstroke. The secret to toning paper evenly is to work quickly, making smooth horizontal brushstrokes.

2 ▲ Be sure to let your paper dry thoroughly before painting on it. The reason for using acrylics rather than watercolors for toning is that there is a slight danger that a watercolor base might dissolve when you paint over it. Acrylic paint will not be re-soluble after it has dried, so it will be fine to paint on.

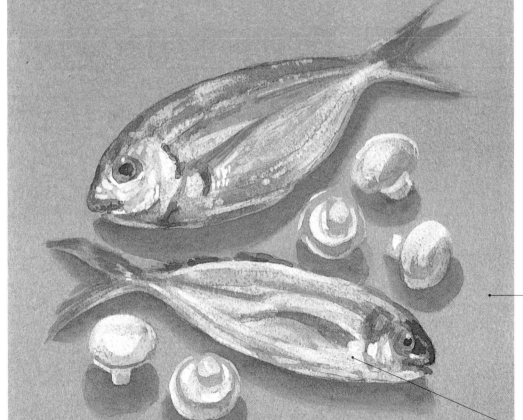

Painting on toned paper
Although sketchy, the still life has quite a finished appearance because of the colored background. The artist has painted on the blue acrylic toned paper, using watercolors for the darker areas and white gouache for the highlights.

See how much lighter the background is once the paint has dried. You will need to allow for this when you tone paper yourself, whether you are using a watercolor base or an acrylic one.

The use of gouache for the highlights on the two fish and on the mushrooms is particularly effective. Pale watercolors would be lost against the strength of the background.

GALLERY OF PAPER

THE WAY YOUR WATERCOLOR PAINTING looks depends as much on the paper you use as on the way that you paint. A weakly sized absorbent paper will give a completely different look than will the same manipulation applied to a hard, surface-sized paper. The texture of the paper will similarly affect the appearance of the paint, with a rough surface giving a more textured look than that achieved with a smooth, hot-pressed surface, because the heavier pigments settle into the hollows of the paper. Another factor to consider is the color of the paper. The use of toned paper opens up a whole range of possibilities, including the use of bodycolor for highlights and a more low-key approach.

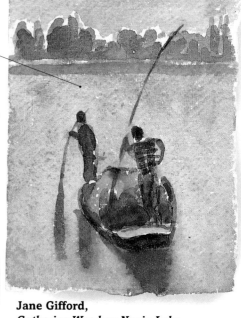

Although the paper is made by hand, there is nevertheless a regularity to the pattern that shows in the finished image.

The texture of the paper absorbs some of the paint and encourages a certain degree of bleeding of colors.

Jane Gifford,
Gathering Weed on Nagin Lake
Painted on rough handmade Indian paper, the water in this Kashmiri scene appears slightly choppier than that in the similar study on the right.

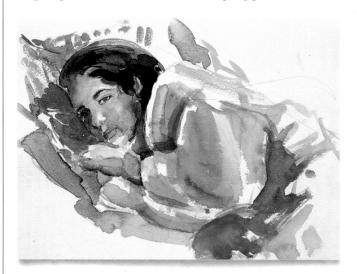

Sharon Finmark, *Portrait of Lia*
Many watercolor painters who enjoy the traditional transparent use of the medium tend to avoid toned paper, believing that it will adversely affect the appearance of the color. But, as with this sensitive study, the buff-toned paper actually creates a subtler and more effective backdrop than would a white ground. So in the areas that have been left unpainted, both to frame the girl and to act as highlights, it is the warmth of the paper that serves to harmonize and unify the whole.

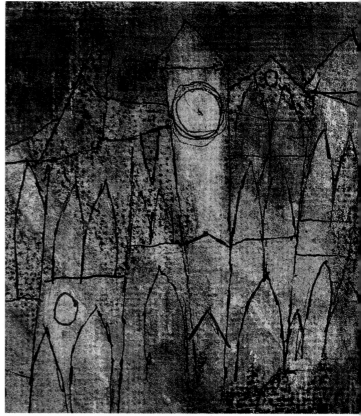

Paul Klee, *Das Schloss*, c.1925
Throughout his life, Paul Klee was fascinated by the materials and techniques of painting, and his work reflects that interest. His constant experimentation with watercolors made him acutely sensitive to the innate quality of each new color and to the texture of a particular

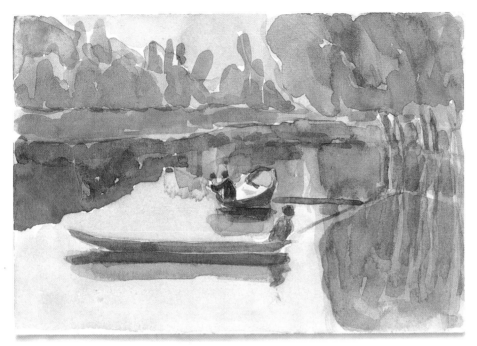

Jane Gifford, *Two Shikaras on Nagin Lake*
This sketch, done on location in Kashmir, seems altogether more peaceful than the one on the left. Gifford uses the smooth surface of the paper to emphasize both the clearness of the sky and the glasslike quality of the water as the boats glide along its surface.

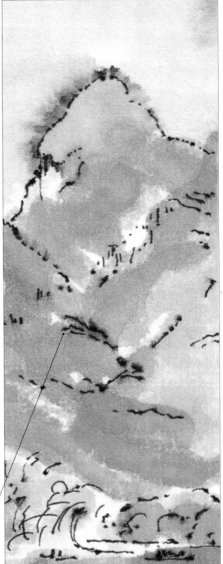

Here the unsized paper dictates the nature of the painting, creating a typically Chinese effect. The washes of paint are absorbed immediately into the paper, but even the ink lines, applied lightly with a fine drawing nib, bleed the moment the ink touches the paper.

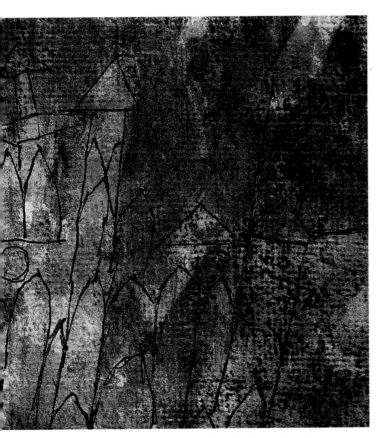

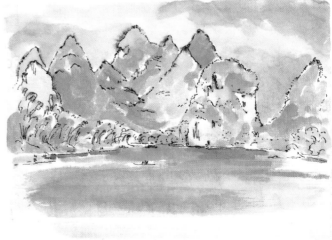

piece of paper. It was factors such as these that led to the unique quality of his vision and his painting. Absolutely integral to the feel of this image is the heavy laid texture of the paper. The paint settles in its hollows and the scene is given a rough, grainy feel. The strong, scratchy ink line is the web holding this image together.

Jane Gifford, *Near Yangshuo, China*
An absorbent paper can give a softer, more diffused look than can a hard, surface-sized paper. This Chinese handmade paper automatically creates a Chinese-style painting. The quality of the paper prevents techniques such as washing off or masking.

WAYS OF WORKING

IT IS USEFUL TO HAVE a certain amount of knowledge about the tools and materials of watercolor because this allows you to make appropriate decisions about which colors to use, for example, or which type of paper would be best in a given situation. But far more than this, you need to practice working with watercolor so that you get a real feel for the medium, rather than just understanding it intellectually.

Two basic brushes

An image made with a cow gum eraser

Gaining confidence

Essentially, the art of watercolor painting is about developing an ability to allow the paint to do its own thing while at the same time remaining in control of the process. Gradually you will start to recognize what is going on in your painting and will respond to it instinctively. What begins as a somewhat self-conscious process, as you attempt to make the right decisions about your painting – what colors to use, the degree of dilution, the type of brush, and so on – ends up becoming a much more intuitive one. You will start to recognize what your painting needs at any given moment without necessarily having to think about it. And with experience you will know both what particular colors or techniques are called for and also be able to put that knowledge into practice.

Controlling the medium

At its most complex, the watercolor medium can be extremely testing because it relies on such a high degree of control. It involves control over the amount and density of paint in the brush; control over how the brush applies the paint to the wet or dry surface of the painting; and control in modifying and moving the paint around on that surface. Many of the techniques associated with watercolor require the rapid and spontaneous application of color, and in some instances there is only one

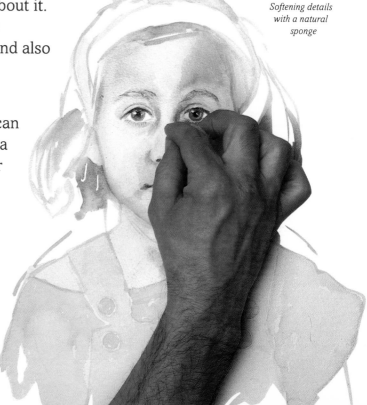

Softening details with a natural sponge

opportunity to get it right, if the whole thing is not to be washed off under cold water and begun again. But it also provides opportunities for artists who wish to create complex works involving, for example, building up layer on layer of thin washes of color using small and precise brushstrokes. In addition, there are a number of specialist techniques such as "stopping out" (*see* pp.60-61) and "wax resist" (*see* pp.62-3), in which different materials and skills are used in a painting to retain the original color of the paper or of a previous wash.

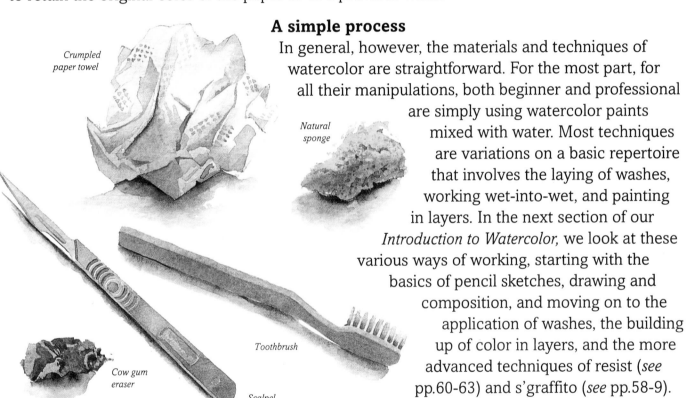

Masking fluid and a dip pen

Crumpled paper towel

Natural sponge

Cow gum eraser

Toothbrush

Scalpel

Sandpapered surface

A simple process

In general, however, the materials and techniques of watercolor are straightforward. For the most part, for all their manipulations, both beginner and professional are simply using watercolor paints mixed with water. Most techniques are variations on a basic repertoire that involves the laying of washes, working wet-into-wet, and painting in layers. In the next section of our *Introduction to Watercolor,* we look at these various ways of working, starting with the basics of pencil sketches, drawing and composition, and moving on to the application of washes, the building up of color in layers, and the more advanced techniques of resist (*see* pp.60-63) and s'graffito (*see* pp.58-9).

Reaping the benefits

It may take time and practice to learn these skills so that the paint does what you want it to do and expect it to do, but the medium is rewarding right from the start. You will soon discover that watercolors can provide a satisfying and versatile challenge, as much to the beginner as to the more advanced artist.

CAPTURING AN IMAGE

APART FROM MAKING PENCIL SKETCHES, artists today have a range of mechanical devices with which to record a scene, from simple drawing frames to cameras, camcorders, or slide projectors. Artists can project slides onto a screen and trace them or color-copy photographs, enlarging those areas that interest them the most.

Zoom lenses
Many cameras now have zoom facilities or wide-angle lenses so that you can get very close to a scene or record a much wider area, depending on what you want to record.

Drawing frame
You can use a drawing frame as a viewfinder, dividing the scene in front of you into manageable sections and then copying the grid onto a sheet of paper to guide you. You can make your own drawing frame by outlining a grid on a sheet of acetate.

Masking out
There may be details in your photo that you wish to exclude, in which case the simplest method is to mask them out. Here the artist wants to focus on the two girls with the rabbit, so she has "framed" the area she is interested in.

Color photocopies
The advantage of working from a photograph is that you can make a color copy of your print and then enlarge it (or a section of it) without losing quality. The larger of the two copies below has been blown up to 400 percent.

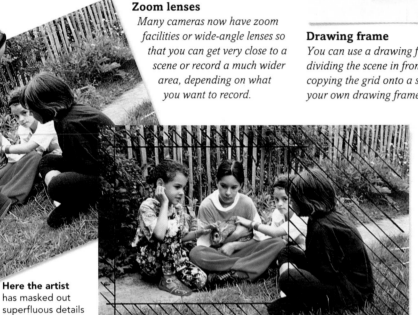

Here the artist has masked out superfluous details on the photo.

Tracing paper
If you lack the confidence to draw your image freehand, you can trace it from a photo. To tranfer it to your paper, copy the lines onto the back of the tracing paper, place it on your sheet and rub over the pencil lines.

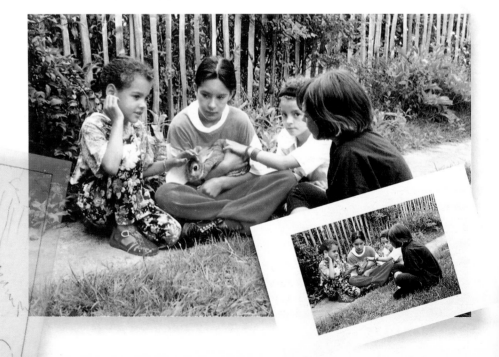

THERE ARE NO RULES about how you should start your painting. If you feel sufficiently confident, you can do a pencil drawing directly on your sheet of paper, or even start painting immediately. But if you prefer to work from a photograph, or even to trace an image on your paper before you start, that is also fine. For centuries, artists have used whatever aids were at their disposal. Albrecht Dürer *(1471-1528)* illustrated a framed grid as a drawing device, and Vincent Van Gogh *(1853-90)* had a portable grid made up for him by a blacksmith. Today, with all the technological advances that have been made, there are even more tools to play with.

VIDEO CAMERAS

Artists of today can use home video cameras to record scenes they might wish to paint later. Often the camera lens sees more clearly than the eye, having the facility to take close-ups and focus in on the smallest details. Depending on the type of camera, video tapes can then be projected onto a screen or run through a television. Either way, it is generally possible to freeze-frame a scene and then trace or copy it onto a sheet of paper. You can then enlarge or reduce your image by using the grid method outlined below.

The grid method
This is the means of transferring an image onto your paper. You can either draw a grid of squares on your original or on a sheet of acetate that you place over your original. You then draw an identical grid on your sheet of paper, although it may be considerably larger if you want to scale the image up. You can then refer to the grid on the original and plot the outlines square by square on your paper.

Ruler and pencil

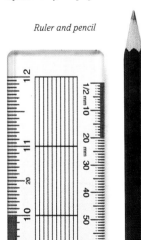

Painting by numbers
By numbering along one side of your grid and putting letters down the other, you can plot your picture more easily. Detailed areas of the original may need more squares. Here, for example, the girls' faces have more squares to make it easier to paint them.

COMPOSITION

KNOWING HOW BEST TO COMPOSE your painting is often surprisingly difficult, but there are some guidelines that are worth following. The position of the horizon line is critical. Looking down from a high vantage point will give you a high horizon line, and consequently you will be able to map out the whole landscape or seascape like a carpet on your painting. A low horizon line, which allows you to look up at the scene in front of you, gives you an opportunity to make the most of the sky. It also means that large objects in the foreground will have the effect of towering above you. It is best to place points of visual interest slightly off-center and to avoid placing the horizon line right through the middle of the painting.

THE POSITIONING OF the main features of your composition does not have to follow a particular pattern, but artists generally try to achieve a sense of balance. This can be done intuitively – if it feels right, it probably is right. Such a balance can emerge from the fact that tones are deeper in the foreground and become progressively lighter toward the horizon. Or the sense of balance might be due to the relative weight of certain features in the painting. For example, an artist might feel that the massive shape of a tree on the left needs to be balanced by something on the right.

Sketching in pencil

A vast panorama
Here the artist wanted to capture the vastness of the scene in front of her. The focal point of the hilltop village is slightly off-center, and the rooftops lead the viewer in a meandering line, from foreground to background.

Focal point
An alternative composition would be to place a large object, such as a tree, on a point off-center to the right or left, planted low but extending almost to the top edge. This would provide a focus or a pivot from which the rest of the composition would flow. Try looking at the painting and altering the edges with pieces of thick paper so that the tree is right in the center – you will see how much less subtle it is.

Playing with perspective
It is generally best to avoid placing the horizon line right through the middle of your painting. In the example above, the sky detracts from the points of interest; the low vantage point in the view on the right is far more dramatic.

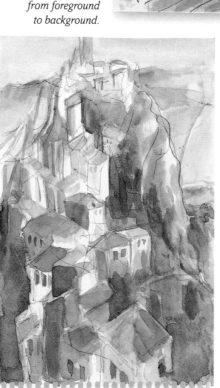

OPEN AND CLOSED COMPOSITIONS

In an open composition, the scene that you see is clearly part of a larger scene, while in a closed one what you see is all there is, like looking at a fish tank. Most compositions have elements of both. The important thing is not to let a key element of your composition slide off the page.

Closed composition

Open composition

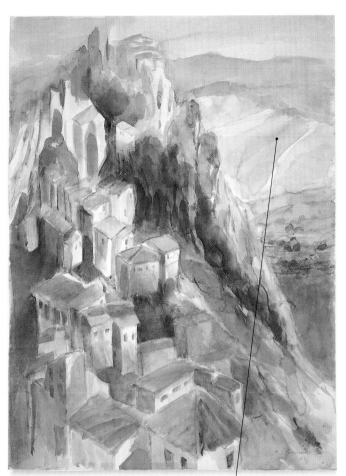

The final painting
The artist selected this view for her finished painting, opting for the high horizon line to capture the sense of the village reaching heavenward. There is virtually no sky, and we are drawn up and down the scene in an upside-down "V" shape as we follow the line of the rooftops up and the trees back down again.

Here note both a visual harmony in the balance of shapes and forms and a color harmony in the balance of reds to greens. The background hills provide a resting point for the eye.

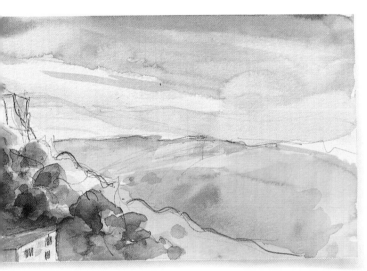

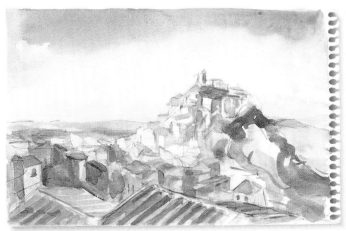

A sense of balance
In this composition, the artist has placed the focal point of the village slightly to the right of center, with the horizon line in the middle of the page. Although a centered horizon is something that should generally be avoided, it is not oppressive in this case because of the lightness of the sky. The viewer is led from the distant building on the summit of the hill, across the rooftops to the left of the page, and then on toward the nearest roof on the right. We are poised above the roof, looking out. The artist has achieved a sense of balance in the colors she has chosen, as well as with the positioning of the scene.

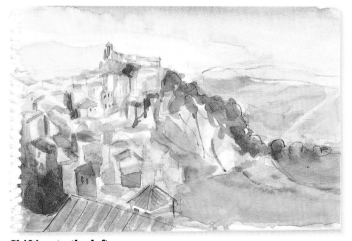

Shifting to the left
Here the points of interest are on the left-hand side of the painting. The horizon line has been moved up, so the sense of perspective is somewhat distorted as we look both down on the foreground buildings and up at the ones in the distance. The sun-drenched hills on the right tend to be more of a distraction than a harmonious counterpoint to the village.

DRAWING

DRAWING AND SKETCHING are an integral part of watercolor painting. Armed with just a sketchbook and a pencil, you can record the main features of a picture swiftly, or in greater detail. You can make notes about the particular colors and tones if you are going to translate your sketch into a painting later. Whatever your chosen method, making initial drawings gives you the space to reflect on what the focus of your painting should be and will tell you fairly quickly if something is going to work well as a final composition.

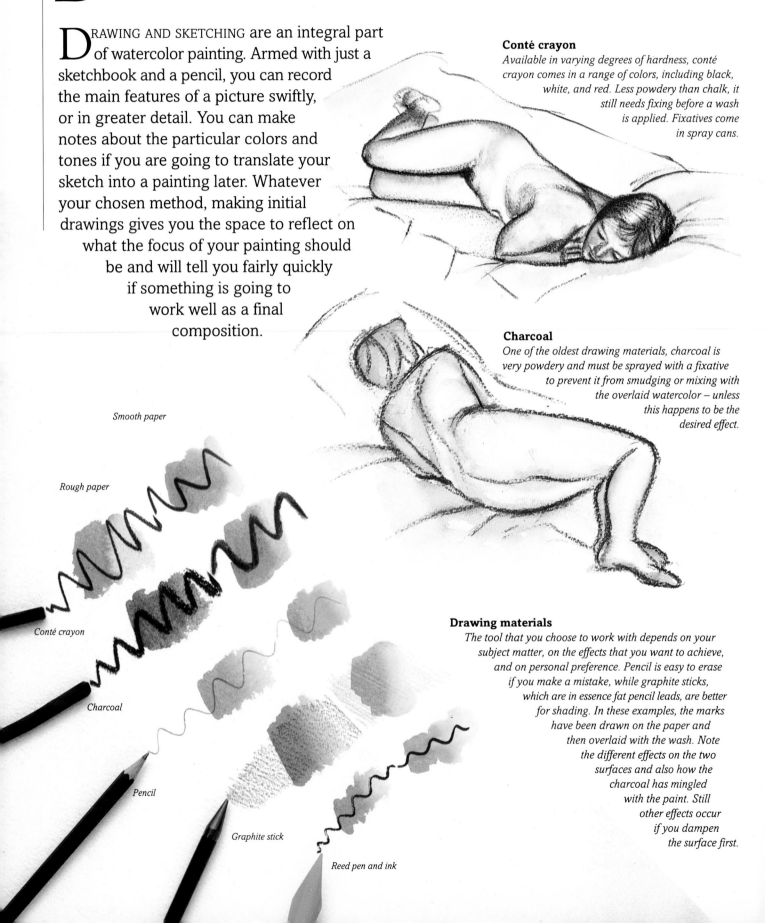

Conté crayon
Available in varying degrees of hardness, conté crayon comes in a range of colors, including black, white, and red. Less powdery than chalk, it still needs fixing before a wash is applied. Fixatives come in spray cans.

Charcoal
One of the oldest drawing materials, charcoal is very powdery and must be sprayed with a fixative to prevent it from smudging or mixing with the overlaid watercolor – unless this happens to be the desired effect.

Smooth paper

Rough paper

Conté crayon

Charcoal

Pencil

Graphite stick

Reed pen and ink

Drawing materials
The tool that you choose to work with depends on your subject matter, on the effects that you want to achieve, and on personal preference. Pencil is easy to erase if you make a mistake, while graphite sticks, which are in essence fat pencil leads, are better for shading. In these examples, the marks have been drawn on the paper and then overlaid with the wash. Note the different effects on the two surfaces and also how the charcoal has mingled with the paint. Still other effects occur if you dampen the surface first.

A PENCIL DRAWING can serve a variety of purposes, and different kinds of pencil are appropriate in each case. The traditional sketching pencil has a soft, fat lead that is good for tonal studies, but if you are making an essentially linear drawing you might prefer a clutch pencil with a relatively thin (.5 mm) lead no softer than about a B. Artists soon develop their own way of making drawings, but if you are not used to making pencil sketches, practice by making drawings of some small, simple objects. Before you begin, try to see the outline of the whole thing and then look to see how various lines and curves within the overall shape define the kind of object it is. It is best to start on a small scale before embarking on a larger picture.

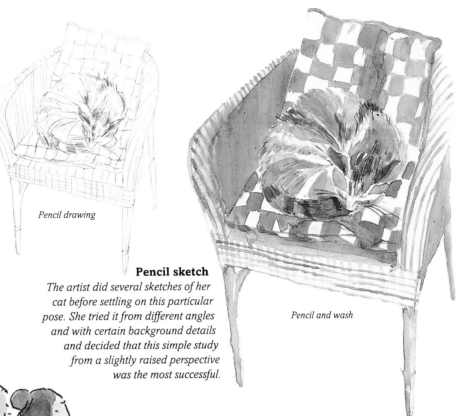

Pencil drawing

Pencil and wash

Pencil sketch
The artist did several sketches of her cat before settling on this particular pose. She tried it from different angles and with certain background details and decided that this simple study from a slightly raised perspective was the most successful.

Pen and wash
These two figures work well both as a simple pen and ink drawing and with the washes of watercolor. The latter has a greater solidity to it, but the line drawing has its own charm. Most drawing inks will not run or dissolve once they are dry, so there should be no problem in putting layers of paint over an ink sketch.

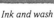

Ink drawing

Ink and wash

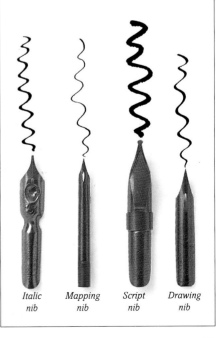

DRAWING NIBS

There are many types of steel nibs that you can use for drawing – it is largely a matter of personal preference. There are the standard drawing nibs and then the script pen nibs, which can also be used. These come in a variety of widths, with or without reservoirs. They all have a springiness in the steel that allows the artist to vary the width and the quality of the line while drawing. Mapping nibs are good for very fine lines, while italic nibs can be either fine or broad.

Italic nib *Mapping nib* *Script nib* *Drawing nib*

LAYING A WASH

A WASH IS A THIN LAYER of watercolor paint, usually applied with a saturated brush over a fairly large area. It can be applied onto dry or damp paper, or it can be overlaid onto dry color already on the paper.

The wash can be manipulated wet, so that particular areas can be lifted and lightened, or other colors can be dropped into it while it is still wet. Alternatively, the wash can be adapted in various ways when it is dry.

How to lay a flat wash

1 ◀ Mix up enough paint before you begin and make sure it is well stirred. You will not be able to stop halfway through to mix more. It is a good idea to use a bristle brush for mixing the paint, as this will break it down more easily. Then for applying the wash, use a soft-hair brush; either round or flat is fine.

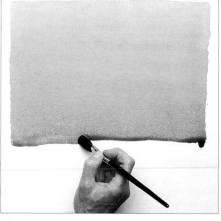

2 ▶ With a saturated wash brush, keep a continuous line of wet color forming along the bottom edge. You may find it easier if the paper is at a slight angle. It is also easier to apply a flat, uniform wash onto a NOT or Rough surface than onto a smooth one, since the smooth surface will show up any streaks.

3 ▲ Pick up the paint with each succeeding stroke. Try to avoid any trickles, and apply the paint in a smooth, continuous motion. You can work left to right or in both directions.

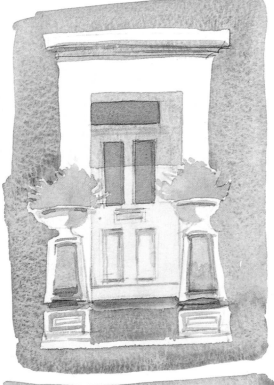

Flat wash
This doorway has been created with washes of flat color, in this case a very dilute mix of Cobalt Blue and Permanent Rose. Note the granulation of the pigment on the NOT (semi-rough) surface.

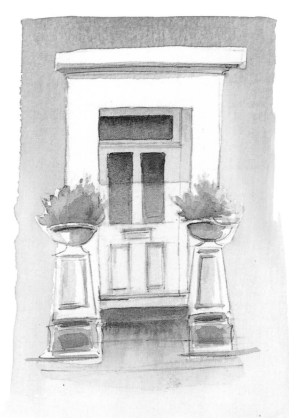

Graded one-color wash
A graded wash is one in which the tone moves smoothly from dark to light. Mixing a light, a mid, and a dark tone of orange in separate saucers, apply the darkest tone first and proceed down the sheet.

Laying a variegated wash

1 ▲ To help the wash flow out, you can wet the area to be painted first, with a sponge or a brush. Then with a soft-hair wash brush, either round or flat, apply your wash of Winsor Blue to the paper.

3 ▲ Working quite quickly, apply some brushstrokes of Lemon Yellow onto the wet surface, in the right-hand corner.

2 ▲ Remember to wash out your brush between colors. Then, starting at the right-hand side, wash in some Violet, touching the Blue in parts and allowing the Violet to diffuse across the page.

TIPS

● Mix up enough paint before you begin, and make sure the mixture remains well stirred, since many pigments have a tendency to settle in the saucer.

● It is a good idea to mix your wash color with a different brush than the one with which you apply it. A bristle brush is best if you are mixing a fair amount of paint from a tube, as you can break the paint down into a well-diluted mix more easily than with a soft-hair brush.

● Many artists like to work with their paper at an angle when applying washes, as this allows them to control the flow of the paint more easily.

● To achieve a more uniform tone, you can dampen your paper before you apply your wash.

● Remember that a watercolor wash dries lighter in tone than it appears when you paint it on, so you should compensate for this in your mix.

4 ◀ Here some areas of Carmine are added at the bottom. All the paints have been applied very wet, and the board has been moved around to allow the colors to flow in specific directions. Note how the different pigments react with each other and also with the surface of the paper.

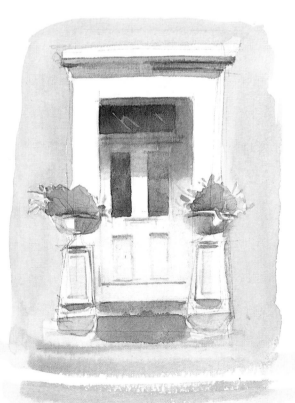

Graded two-color wash

Running one tone into another can be done with two or more colors. Mix sufficient quantities of the colors you require and apply them swiftly, allowing them to mingle and diffuse if you wish.

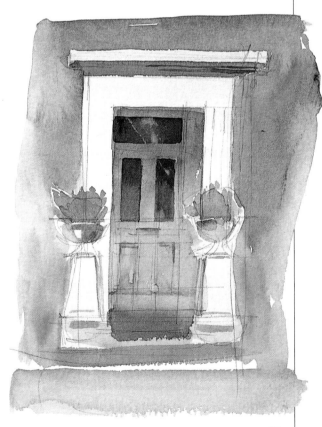

Variegated wash

To wash several colors over areas of your painting, pre-mix the colors and then paint them rapidly up to the boundary of the neighboring color. The colors will then diffuse into each other along the join.

WASHES

WASHES WILL VARY depending on the pigments used, on how they are applied, and also on the quality of the paper. For example, on smooth paper there is a tendency for washes to appear streaky, while on a rough surface they may not penetrate the hollows of the paper. But washes can also be modified while they are still wet. Shapes can be sponged out of a wash, clean water can be dripped into them, or additional colors can be dropped in.

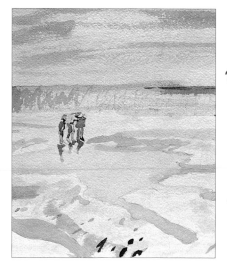

Smooth paper
The colors in the two studies are the same but appear deeper and more vibrant on the smooth paper. Washes should be applied in a continuous, even movement when a smooth paper is used.

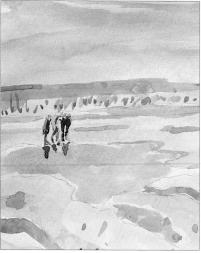

Rough paper
On Rough paper your brushstroke needs to be slower and firmer to ensure that the paint runs into the hollows. In this example, the Rough surface has created a sparkle effect.

Washing off
Sometimes a wash is not successful or the painting has become too dense with pigment to successfully overlay another color. If this happens, you can wash the whole thing off. You should use cold water to avoid removing the surface sizing on the paper. Very often a washed-off painting can look far better than it did before. It may only require minor adjustments to be complete.

The essential feature of a washed-off painting is that the texture of the paper is revealed more clearly since the process takes off the top surface. That is, the raised parts of a Rough or NOT surface will be left pale, while the pigment remains lodged in the deeper crevices of the paper. Washing off removes only part of a color. Once it is lodged in the fibers of the paper, watercolor is very tenacious. Some pigments have more staining power than others, but most resist the effect of washing off to some degree.

TIPS

Mixing up paint

● Use a bristle brush to mix up the paint, but use a soft-hair wash brush, either flat or round, to lay the wash. Make sure you mix up enough paint before you start, as you cannot pause to mix up more while you are in the middle of laying the wash.

● Smooth paper will show up any streaks that have been created by (a) not having stirred up the paint well enough, (b) taking too long to apply it, or (c) pushing down too hard with the brush.

● Rough paper will have a sparkle effect in which spots of white paper show through the wash. If you wish to avoid this, you may need to work back and forth over the same area several times to ensure that the paint gets into the dips in the surface.

Washing off and overlaying a second wash

Pink wash

1 ▲ Using a Rough paper, paint a blue wash over a section of it.

2 ▲ Wash the blue off under cold water, using a bristle brush to help dislodge the paint.

3 ▲ Paint a layer of pink over the washed-off blue. You will produce a grainy purple.

Wash techniques

Although we tend to think of washes as applications of paint that cover large areas of a painting, the technique is equally suitable for smaller areas. For these you simply use smaller versions of the same brushes, in particular, the small round sables. The following swatches are just a few examples of what you can do with washes of color. Some use the tip of the brush, others the toe, and still others involve two brushes being used simultaneously. The possibilities are endless.

A thick application *of Permanent Rose is dragged rapidly across a wet wash of Winsor Blue on a flat 1 inch brush.*

The toe *of a small, round, nylon brush with Permanent Rose is curled swiftly into the Winsor Blue wash to create this suffused vapor trail effect.*

Two drops *of Permanent Rose are dripped into the watery Winsor Blue wash and allowed to spread outward.*

Using a medium-size, *round, soft-hair brush, Permanent Rose is worked rapidly around the edge of this Winsor Blue wash.*

A band of *Manganese Blue and one of Winsor Green are allowed to fuse together. The granulated Manganese Blue wash contrasts with the more even green one.*

Curling a *dark tone of Winsor Green into the granulated Manganese Blue wash gives a very different effect.*

Working simultaneously *with two No.8 round brushes, fully charged with dense pigment, can give these rich effects.*

After the *Manganese Blue wash has been applied, the Winsor Green is scrubbed into the paper with a bristle brush.*

Two colors *have been applied onto a flat 1¼ inch wash brush before being dragged quickly across the paper.*

Separate blocks *of Violet and Rose have been applied and allowed to dry before being joined by using a clean, damp brush.*

One thin stroke *of Violet is followed rapidly by another thin stroke of Winsor Green, to create this layered effect.*

The areas *of Winsor Green and of Violet are allowed to run together to create this densely textured, yet fluffy effect.*

APPLYING A WASH WITH A SPONGE

There are a number of ways of applying washes, from the traditional wash brush, for standard techniques, to small round brushes, for more confined areas, to household wallpaper brushes, for very large areas. Some artists, however, like to work with sponges because it allows them to cover large areas more rapidly and effectively. Try laying a wash with several types of sponges to see which you prefer.

1 *To sponge on a wash, mix up a large amount of color and soak your sponge in it. A small natural sponge is best, but you can use a household sponge for larger areas.*

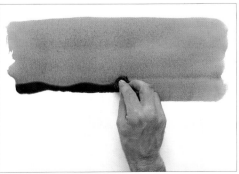

2 *Holding the sponge in your fingertips, rub it back and forth, catching the drips as you go. The technique is to work downward as if you were washing a window.*

GALLERY OF WASHES

S UCCESSFUL WATERCOLOR PAINTINGS depend, to a large extent, on the application of washes. Learning to lay washes is a skill that has to be acquired through practice, as it involves an understanding of the amount of paint required to be held in the brush, the degree of dilution of the paint, the nature and angle of the surface being painted, and the appropriate choice and handling of the brush itself. Washes can be free-flowing over a large area, with color blending into color and with variations of tone, or they can be tightly controlled in small or irregular shaped areas. In addition, they can be manipulated wet, so that particular areas can be lifted and lightened or altered by having additional colors dropped in.

Gisela Van Oepen, *Pays de l'Aude*
This painting clearly demonstrates the effect of working into very wet areas with dense color. This can be done either by laying a clear wash over chosen areas and then dropping in the deep colors or by applying color first and dropping in water or additional colors afterward.

Miles E. Cotman, *A Calm, c.*1840-49
This peaceful scene demonstrates great control in the application of washes. Notice how the uniformity of tone in the wash for the sky is sustained right up to the edges of the clouds. There are no dramatic sweeps of the brush – just the kind of consummate skill that allows the image to speak for itself.

Two washes of color, carefully controlled, are all Cotman needed to realize this sailing vessel in the distance.

Jane Gifford,
Street Scene,
Madras
In this simple yet
effective study, the
artist has carefully
applied her washes in
a form of "patchwork"
to indicate the broad
masses of color on
the scene. She has
allowed the washes
to move around
freely in areas where
it is appropriate to
the subject to do so,
as on the dome.

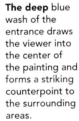

The deep blue wash of the entrance draws the viewer into the center of the painting and forms a striking counterpoint to the surrounding areas.

A couple of broad, loose brushstrokes is all that is needed to suggest this woman in her radiant sari, framed by the darkness of the doorway.

Julian Gregg, *Poppit Sands, Cardigan*
In this loosely worked sketch, there is practically no overpainting, and areas of the paper are left untouched. The artist has applied simple washes along the horizontal axis, allowing colors to bleed into one another wet-in-wet while relying on single, sweeping brushstrokes along the horizon.

Robert Tilling, *Low Tide Light*
Using broad wash brushes, Tilling lays large areas of very wet color across his paper, skillfully controlling the paint. Here the washes are swept across the painting, softening in tone in particular areas to create the effect of the light. Certain colors are allowed to bleed into the next to create an evocative sense of space and mood.

TONE AND COLOR

AFTER LEARNING TO LAY WASHES, the next stage is to practice building up tone and color. The easiest way to approach this is to work initially in tones of one color. In the past, it was quite common for artists to paint monochromatic studies, using colors such as Sepia (a dark reddish brown), made from the ink sac of the cuttlefish, and red and brown earth pigments. Other good colors to practice with are dark green, blue and black.

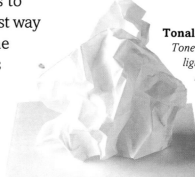

Tonal values
Tone is the relative darkness or lightness of an image. If you look at the crumpled paper, you will see that, although it is white, the play of light over its surface creates a range of tonal contrasts from white to gray. It is these that give the paper its form.

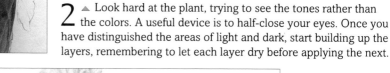

2 ▲ Look hard at the plant, trying to see the tones rather than the colors. A useful device is to half-close your eyes. Once you have distinguished the areas of light and dark, start building up the layers, remembering to let each layer dry before applying the next.

1 ▲ After making a pencil sketch of the plant, apply the palest washes first, in this case a very dilute Indigo, and start filling in the leaves. Notice where the highlights are, and leave these areas white.

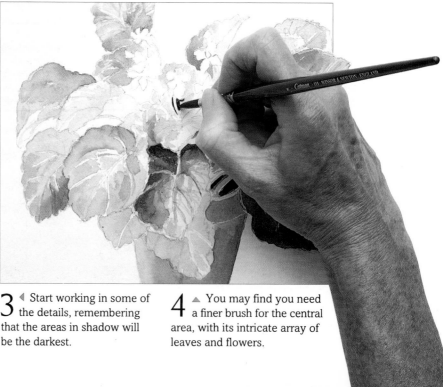

3 ◀ Start working in some of the details, remembering that the areas in shadow will be the darkest.

4 ▲ You may find you need a finer brush for the central area, with its intricate array of leaves and flowers.

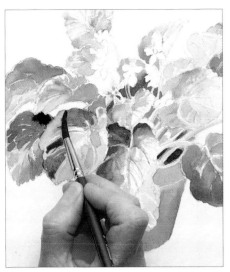

5 ▲ When you apply very wet washes of paint, keep some blotting paper handy in case the color starts to run.

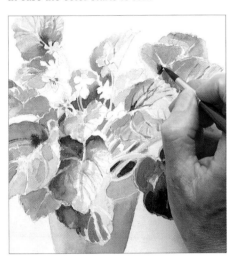

6 ◄ As you work, you will notice that the color becomes considerably lighter as it dries. If you need a darker tone of blue, mix in some Payne's Gray with your Indigo. Use the darker mix for the veins in the leaves and for the areas that are in shadow.

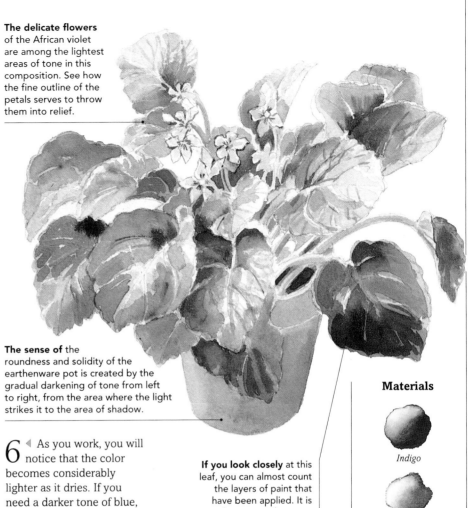

The delicate flowers of the African violet are among the lightest areas of tone in this composition. See how the fine outline of the petals serves to throw them into relief.

The sense of the roundness and solidity of the earthenware pot is created by the gradual darkening of tone from left to right, from the area where the light strikes it to the area of shadow.

If you look closely at this leaf, you can almost count the layers of paint that have been applied. It is the contrast between these very dark areas and the lighter ones that give the plant study its three-dimensionality.

Materials

Indigo

Payne's Gray

No.8 round

OVERLAYING A WASH

Although monochromatic painting is a rewarding technique in its own right, and one with a rich and celebrated history, watercolor painting is more traditionally associated with overlaid washes of color. To get a clearer idea of the nature of watercolor and the way in which each overlaid color affects the one below, do a simple painting in tones of one color and see what happens when you lay a wash of a different color over it. In the example below, the yellow landscape is transformed by the application of a Cerulean Blue wash. Note how the blue over the different shades of yellow results in a broad range of greens, even though no green was applied.

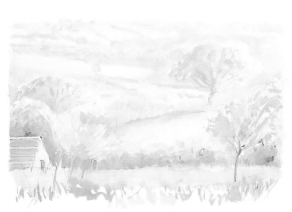

Range of yellows, Burnt Sienna, and Raw Umber

Swatches with overlaid blue

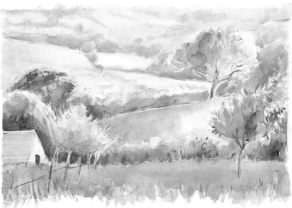

Effects of Cerulean Blue applied over yellows

BUILDING UP LAYERS

TRADITIONALLY, WATERCOLOR PAINTING is built up in stages. Since the watercolor medium is generally characterized by transparent color effects, with the color of the paper underlying all the painting, the overlaying of color is really a form of glazing. Any number of colors may be glazed over each other, and each will affect the look of the whole. The most important feature of the technique is that each color beneath must be completely dry before you paint over it.

Testing colors
It is good practice to try your colors out, both singly and by overlaying them, before committing them to your actual painting. These are the colors used for the painting of the lighthouse.

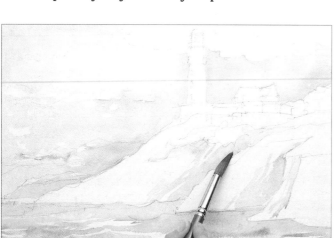

1 ▲ In this exercise, you will see how you can create a painting by building up washes of color. First, with a No.12 wash brush, fill in the sky, sea, and cliff areas with a mixture of Cobalt Blue and Payne's Gray.

2 ▲ Once the blue has dried, mix up a wash of Alizarin Crimson and fill in some of the sky area and more of the cliffs. See how the blue shows through the pink and how it is affected by this single layer of overpainting, taking on a purplish hue.

3 ▲ To warm up the color of the cliffs, add a wash of Raw Sienna. Use this color also for the basis of the lighthouse, the trees, and the grassy areas.

4 ◀ Again allowing the Raw Sienna to dry, add a layer of Prussian Blue over the trees and grass, building up those areas that need to be darker. Note how the blue over the yellow results in a green, the hue depending on the relative strengths of each.

COMPLEMENTARY COLORS

The balance of complementary colors plays an important part in painting techniques. If, for example, you are painting a predominantly green landscape, you can create a subtle balance in the color by laying a bright green wash, letting it dry, and overpainting it with a red one.

In the scene shown below, the sky as well as the foreground area have been overlaid with a red wash, with the poppies forming the final detail. The overall effect is to warm up the landscape, heighten the sense of perspective, and greatly enrich the feel of the work.

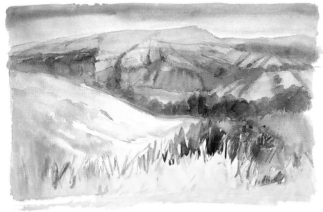

Landscape in blues and greens

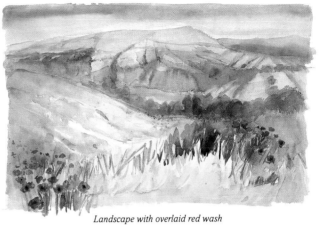

Landscape with overlaid red wash

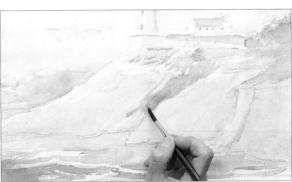

5 ◀ To strengthen the tone of the sea, add a second layer of Prussian Blue mixed with Indigo over some of the foreground waves. You will see that the colors appear brighter while the paint is wet, so you may need to deepen certain colors once your painting has dried.

Lighthouse study
Final touches of blue have been added to give definition to the windows and bring foreground areas into sharper focus.

Note how areas have been left so that the white of the paper forms the clouds and sides of the buildings.

Materials

Cobalt Blue

Payne's Gray

Alizarin Crimson

Raw Sienna

Prussian Blue

Indigo

No.8 sable / synthetic

No.12 synthetic

SPONGING OUT

FOR CERTAIN EFFECTS, you may need to modify your painting while it is wet, or even after it has dried. For example, you might want to create shapes that are lighter in tone in a certain area. In such a case, it is often easier to apply a broad wash of color over a complete section of a painting rather than trying to avoid or paint around certain areas.

You can subsequently sponge out or blot out those areas that need to be lighter, a technique known as lifting off. You can do this when the paint is wet or after it has dried, depending on which method is more convenient. The effect is largely the same, although lightening areas after the paint has dried may require some vigorous brushwork to dislodge the pigment.

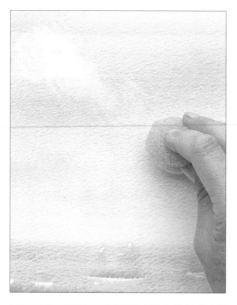

1 ◀ To sponge out cloud shapes, apply a wash of Cerulean Blue plus Mauve with a medium-size brush. While the paint is still wet, dip a small natural sponge in water, press it onto the blue wash, and remove it in one movement. The sponge will lift off the blue wash.

2 ▶ To practice sponging out from dry paint later, lay a green wash for the bank of the river, making some of the hills in the distance a little darker. Once this has dried, fill in the tree and grass details with a rigger – a fine, pointed brush with long hairs.

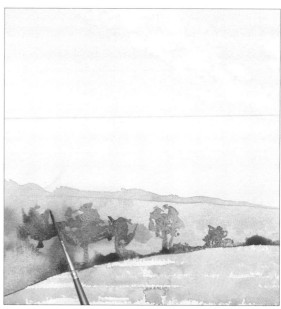

3 ◀ Wet your sponge and press it on an area of the sky, holding it there for a moment to loosen the paint. Lift the sponge off, and press a sheet of paper towel onto the area that has been wetted. Remove the paper towel to lift the paint off. The sponge will have created cloudlike forms.

4 ▲ To accentuate the shape of the clouds and build up the sky, mix up some Burnt Sienna and Cerulean Blue. With a medium-size brush, apply your blue wash to the sky, painting around the whited-out cloud areas in order to create shadows and give them a sense of three-dimensionality.

EXAMPLES OF LIFTING OFF

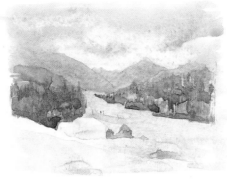

Lifting with brush from dry paint
Here the clouds have been created by working into the sky with a wet bristle brush until the paint has loosened sufficiently to be removed. To dislodge dry paint, you will need to use your brush quite vigorously. Some pigment may remain in the paper.

Lifting with paper towel from dry paint
A wet sponge has loosened the dried paint of the sky after which the clouds have been lifted with a paper towel.

Sponging out from wet paint
Here the clouds have been sponged out using a moistened sponge on wet paint. The sponge has been rubbed onto the blue wash and lifted off, taking some of the paint with it. Notice the soft, diffused effect the sponge creates, particularly in comparison to the other methods of lifting off.

5 ▷ In order to lighten the foreground grass, load your brush with clean water and draw it across the area of dry color you wish to modify. While the water seeps in, work your brush between the trees to create greater definition between them. The degree to which you can wash areas out of your painting will depend on the staining power of the pigments you have used.

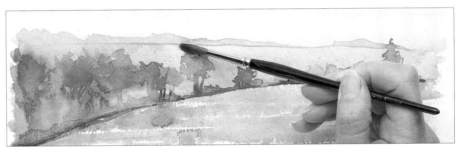

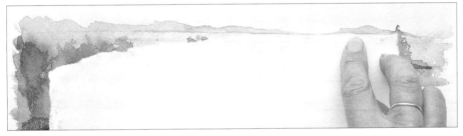

6 ◁ Press a sheet of blotting paper onto the wet grass, and then remove it. A good deal of the paint will come off. Repeat the process between the trees, first wetting the area you wish to modify with a brush dipped in clean water and then blotting it off with the blotting paper. You may be able to lift a tree out completely in this way.

Riverside study
In this finished version, you can clearly see those areas that have been lightened – the clouds, the foreground grass, and the details between the trees. What you cannot tell is which areas have been modified while wet and which while dry. It does not make much difference which way you choose to work. It is largely a matter of personal preference and convenience. If you are doing a quick study outdoors, you might even sponge out shapes when you get back to your studio.

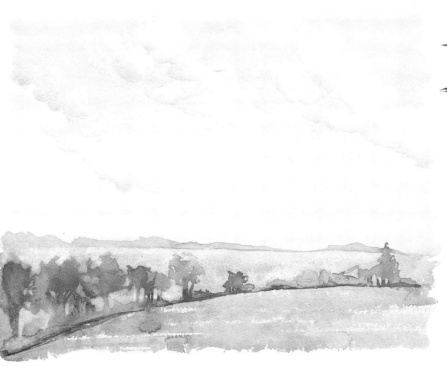

Materials

Rigger

No.6 sable

Natural sponge

Blotting paper

SCRATCHING OUT

Cornish graveyard

IN WATERCOLOR PAINTING, the technique of scratching out is a means of getting back to the white of the paper or to the dried paint film underneath the one that has just been applied. It can be used for highlights or for particular effects and is as applicable to wet paint films as it is to dry. With wet paint, the technique is to scrape the surface with the blunt blade of a penknife, taking care not to cut the paper. With dry paint, the method is to physically skin the dry paint off of the area you want to reveal. The way you handle your blade – using gentle strokes or vigorous ones – will determine the look of the technique.

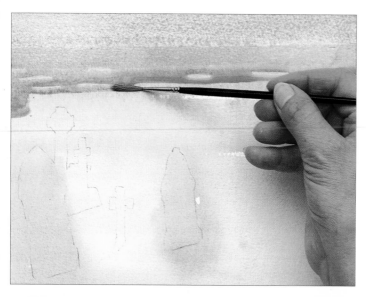

1 ◄ Using Rough paper, apply a wash of Raw Umber with a 1 inch brush, starting at the horizon. Dilute the paint as you work your way down; a somewhat patchy effect is fine.
Once this has dried, draw a faint pencil outline of the gravestones. Next, take a small round brush and paint a wash of Cerulean Blue over all of the paper, taking care to avoid the gravestones. Apply the blue in loose horizontal strokes. You may have to go over certain areas since paint dries lighter than it appears when it is wet.

2 ▲ Once the paint has dried, cut a piece of medium grade sandpaper and wrap it around your pencil. Then, using the sandpapered surface, gently scratch the three front stones.

3 ▲ Build up the grass area by adding layers of Aureolin – a bright yellow – and more Cerulean Blue, always allowing the paint to dry between layers. You may use a hair dryer on cool to speed up the process.

Next, take a craft blade and use it to scratch highlights in the sea, pulling the blade down in short vertical strokes (or horizontal ones for headland waves). Notice how the blade reveals the Rough surface of the paper.

4 ▲ Mix Cerulean Blue and Sepia and use your fine, pointed brush to build up the background details. Now take a wet sponge and rub it over an area of dried paint to sponge out another gravestone.

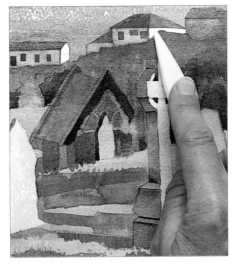

5 ▲ Take a scalpel and gently score around the side of the house, cutting just deep enough to remove the surface of the paper without cutting right through it. Using the blade or a pair of tweezers, lift off the sliver of paper.

6 ◀ Do the same on the second house. The act of skinning these surface layers raises the nap of the paper. You need to burnish (rub down) the paper that you have revealed with your nail or the flat of a paper cutter. This is particularly important if you want to overpaint the area later.

Materials

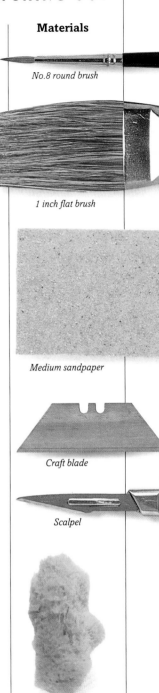

No.8 round brush

1 inch flat brush

Medium sandpaper

Craft blade

Scalpel

Natural sponge

Paper towel

7 ◀ To lighten the blue of the horizon and create a feeling of distance in your painting, dip a flat wash brush in clean water and draw it over the area that you want to modify. Allow the water to seep in for a moment.

8 ◀ While the surface is still wet, press a paper towel over the area and then lift the towel off. You will see that the towel removes some of the loosened paint. If you want to make the horizon even lighter, roll a small piece of soft bread over it while the paint is damp. You will find that this picks up still more of the pigment.

Finished work

For the final touches, the artist has used the wooden end of the brush to "cut" blades of grass in the foreground area while the paint is still wet. She has also rubbed sandpaper over the dried paint film of the gravestones, to give them their characteristic coarseness.

Sanding down certain areas of the grass reveals the roughness of the paper surface.

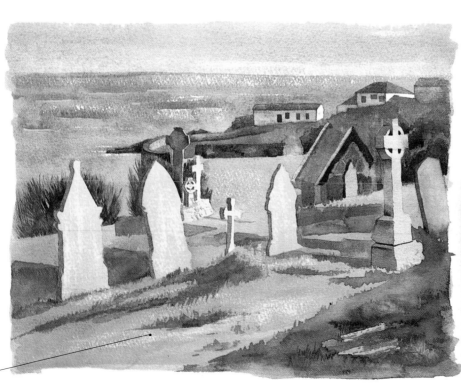

RESIST TECHNIQUES

Pencil sketch

IF YOU WISH to protect certain areas of your painting so that you can paint over them without disturbing what lies beneath, you can use a method known as masking or stopping out – a "resist" technique. This involves applying masking fluid.

Once the fluid has dried and you have painted over it as much as you wish, you can rub off the masking fluid to expose the protected area of the painting. Masking can be used for highlights, as a means of keeping the paper white, or for safeguarding an area that is light in tone while you deepen the tones around it.

USING MASKING FLUID

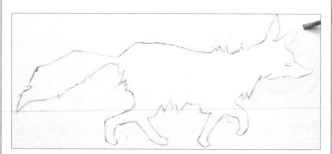

1 Do a pencil drawing of your fox and carefully mask around the edge. Here it has been done in two stages, first with masking fluid applied with a dip pen and then more loosely with a brush.

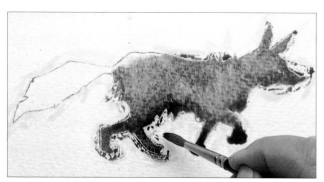

2 Let the masking fluid dry and then dampen the area inside it so that the colors will merge when you apply them. Lay down washes of Burnt Sienna, Cadmium Scarlet, and Payne's Gray.

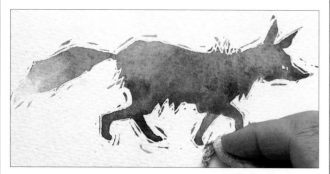

3 Once the paint has dried, gently rub off the masking fluid. You can do this in a number of ways, either with a cow gum eraser, a putty eraser, or simply by using your fingers. You will find that the pencil lines are erased in the process.

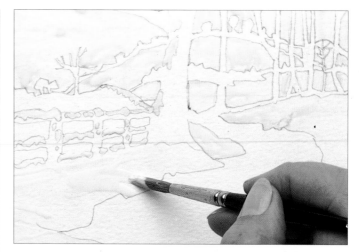

1 ▲ Again, starting with a pencil outline, mask out the areas you wish to protect. As the masking fluid tends to ruin the hairs, you can either use an old brush for this, or protect your brush by rubbing the hairs over a bar of soap before you start. Always wash the brush in warm soapy water as soon as you've finished.

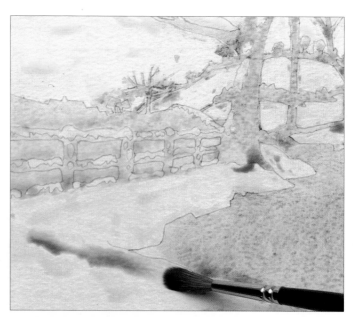

2 ▲ Let the masking fluid dry naturally or speed the process up with a hair dryer. Then, using a medium-size brush, apply a wash of Cobalt Blue and Burnt Sienna over the unmasked areas.

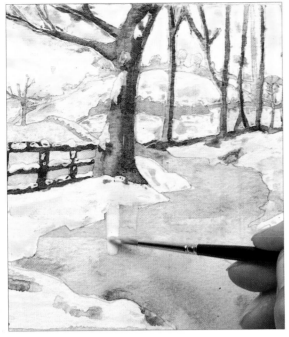

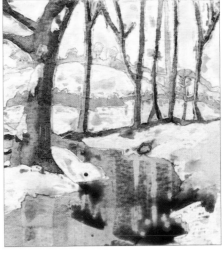

CARE OF YOUR BRUSH

Use an old brush for applying masking fluid and always wash it out in warm soapy water between applications. If you use a good brush, rub the hairs with wet soap before you start. This offers some protection as it prevents the masking fluid from clogging up the ferrule and adhering to the hairs. The lower brush was treated in this way, while the top one shows the effects of masking fluid having dried and coagulated on the hairs.

4 ▲ Dry the masking fluid with a hair dryer. You can test it to make sure it is dry by touching it lightly with your fingertips. Next, deepen the tones of the river with another Burnt Sienna and Cobalt Blue wash.

3 ▲ Apply more washes of Burnt Sienna and Payne's Gray to darken the tones of the trees and the fence, allowing each layer to dry between applications. Then mask out areas of reflection in the river using an old, smallish brush. Wash the brush in warm soapy water as soon as you have finished, to stop the masking fluid from ruining the hairs.

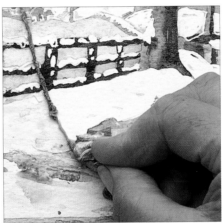

5 ◀ Lift off the masking fluid with a cow gum eraser or a putty eraser. Once it has been removed, fill in the sky with a wash of Alizarin Crimson, Cobalt Blue, and Burnt Sienna.

Masking fluid gives a hard edge to any shape that is masked out, a characteristic that can be seen most clearly in the snow-covered fence.

The sky is the final detail to be painted, having been masked from the outset.

Materials

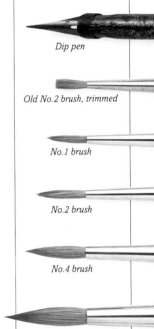

Dip pen

Old No.2 brush, trimmed

No.1 brush

No.2 brush

No.4 brush

No.6 brush

Winter scene
With the removal of the masking fluid, several things happen: the whiteness of the paper is revealed and the original pencil lines are rubbed out at the same time.

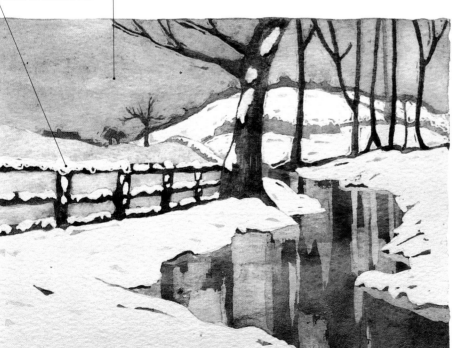

Masking fluid

61

OTHER RESIST TECHNIQUES

For MORE SUBTLE MASKING-OUT effects than those achieved with masking fluid, you can use gouache paint, wax, or gum arabic. The results are slightly different in each case, and the gouache and the gum arabic have to be washed off the paper in order to achieve the resist effect. This means that you are disturbing the color you have just painted on, so remember that when you paint over the masked-out areas, you must use a deeper tone than the one you want to end up with. The effect of washing off gives a slightly softer-edged feel to the masked-out area than you would achieve with masking fluid. If you opt for gouache, it is best to use white. It has the least effect on the colors when it is washed off.

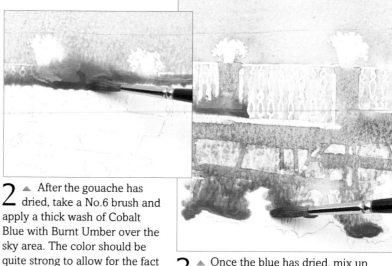

2 ▲ After the gouache has dried, take a No.6 brush and apply a thick wash of Cobalt Blue with Burnt Umber over the sky area. The color should be quite strong to allow for the fact that some of it will be washed off. See how the gouache paint repels the blue and umber wash.

3 ▲ Once the blue has dried, mix up a wash of Burnt Umber. Apply this smoothly and rapidly to the columns and benches so as not to disturb the gouache.

1 ▲ For gouache resist, draw an outline of the balcony details on a Rough paper and plan which areas will need to be masked out. Mix up some white gouache paint relatively thickly, like heavy cream. Then take a very fine brush and paint in the railings and the flower pots, and use a larger brush to paint the balcony floor.

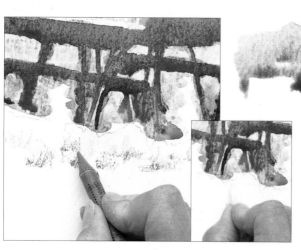

4 ◀ For wax resist, use a sliver of a candle and draw in some foreground grass. Draw additional grass with olive green and light green wax/oil crayons. Both the candle and the crayons will repel washes of color.

5 ▲ Mix up a wash of Burnt Umber and Viridian Green and paint it thickly over the foreground area. Note how the wash refuses to adhere to the wax-resisted surface. Although the effects are quite subtle, if you look closely you will be able to distinguish individual blades of white and green grass once the wash has dried.

Materials

6 ▷ Add another layer of your blue and umber mix to deepen the color of the hills. Allow this to dry. Then lower your painting into water and gently sponge over the whole surface. The process will remove the gouache as well as dislodging some of the paint, but the candle wax and wax crayon will not be affected. Now stretch your paper on a board and leave it to dry.

No.6 brush

No.1 brush

Wax/oil crayons

7 ▲ For gum arabic resist, make sure your painting is completely dry and then draw the outline of the overhanging leaves in pencil. Next mix up a wash of Viridian and Cadmium Yellow with equal amounts of gum arabic and water and apply it to the leaves. You can block in large areas of color, since details of sky around the leaves can be lifted out later.

8 ▲ Allow the paint to dry. It will appear quite shiny because of the gum arabic solution. Now dip a fine brush, perhaps a No.1, in water and "paint" an area in the foliage which you wish to lift off later in order to reveal some sky. Allow the water to sink into the paint for a while.

9 ▲ Now take some paper towel, press it onto the moistened area, and lift off the green paint. Because of the gum arabic, it will come off quite easily, without disturbing the blue beneath it.

Wax candle

Natural sponge

Final touches
Because the washing-off process lifts off some of the paint, details have to be painted in or accentuated later. Here the flowers are painted in Cadmium Scarlet. The columns and the benches are darkened, and the shadows are then added as a final stage.

Gum arabic

The white gouache leaves no trace on the paper and yet effectively blocks out any color. It also creates a much softer edge than masking out with masking fluid.

The wax resist adds texture to the foreground grass.

USING GOUACHE

GOUACHE, OR BODYCOLOR as it is also known, is a watercolor – but it is characterized by its opacity rather than by the transparent effects normally associated with the medium. Because of its different properties, it has specific uses in watercolor painting, for example, to create highlights in a traditional watercolor painting, or to provide a matte and uniformly even tone when that is what is required. It is generally applied more thickly than a regular watercolor and can create a more impasto effect. Because of its opacity, gouache works particularly well, and economically, on toned or colored paper.

SINCE GOUACHE PAINT is used more thickly than traditional watercolor, the paint film needs to be a little more flexible. It also needs to flow well to ensure that it can be brushed smoothly out in flat, opaque tones. Although gouache colors are made in almost exactly the same way as other watercolors, there are certain modifications that make them marginally more soluble than watercolors, an effect that is noticeable when overpainting them.

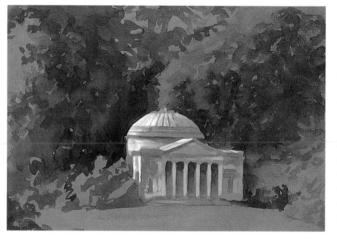

Highlights
Gouache paints are traditionally used for highlights, specifically for picking out details on buildings. Their opacity makes them useful in conjunction with traditional watercolors. In the image on the left, the white gouache creates the sense of form on what might otherwise seem a rather flat, two-dimensional structure.

OVERLAYING GOUACHE

Gouache is, in effect, just another form of watercolor. The paints can be used in the same way as straight watercolor paints, provided they are sufficiently diluted. They can, however, also be used much more thickly, when, for example, a flat uniform tone is required in a particular area, or a more textured look is desired. Between these uses lies a wide range of possible manipulations and effects.

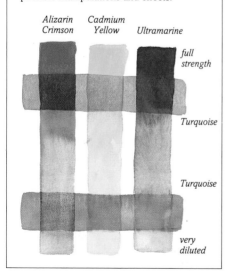

Alizarin Crimson *Cadmium Yellow* *Ultramarine*

full strength

Turquoise

Turquoise

very diluted

Toned paper
Gouache is particularly effective on lightly toned paper where the background color serves to unify the whole. To work in this way, begin by sketching in the main features. Then look for the lightest tones and paint them in by adding a touch of color to the white gouache. Next look for the dark tones and paint them using a more watery mix as above. Although similar to using oils as a technique, the finished appearance is quite different and displays a characteristic chalky matte quality.

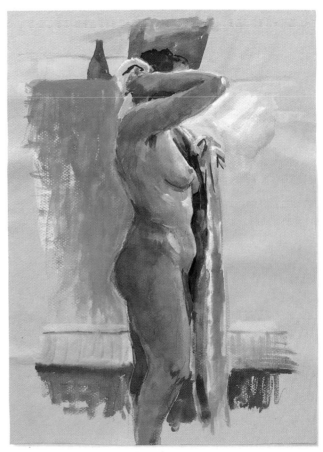

High pigment loading

The opacity of gouache is often obtained by incorporating very high levels of pigmentation – far more than in watercolor. Gouache paints work well in washes, so they can represent good value for money as an alternative to watercolor.

The opaque nature of gouache means that for certain colors there is no other way to get a high level of brightness than to use brilliant but very fugitive pigments. Such colors may be fine for illustrators, whose work is designed for reproduction, but there is no point in using them in artwork that you wish to be permanent. It is a therefore advisable to check the durability rating before you purchase a gouache color.

Transparent and opaque

Gouache can be used in conjunction with transparent techniques or on its own, as in this nude study. Here the artist has exploited the diverse nature of gouache by using it both thickly, as in the face and neck area, and highly diluted, as in the legs. Generally, however, she has chosen to use it more like a traditional watercolor than as an opaque painting medium.

A versatile medium

Having said that, gouache, with its wide range of manipulations and uses, is somewhat more versatile than traditional watercolor paints while being equally easy to handle. It has been used for such a diverse range of subjects as small-scale Indian and Persian miniatures and large-scale studies for oils. When used on a large scale, gouache paints are generally applied with bristle brushes. These are particularly good both for breaking down the paint and for blending it.

Although gouache can be used on its own, either thickly or thinly as in the two examples on this page, it can equally be used in conjunction with traditional watercolors. Indeed, some contemporary artists have made a point of juxtaposing the transparent and opaque techniques of the two forms of watercolor paint in the same work, in order to exploit their different natures and effects.

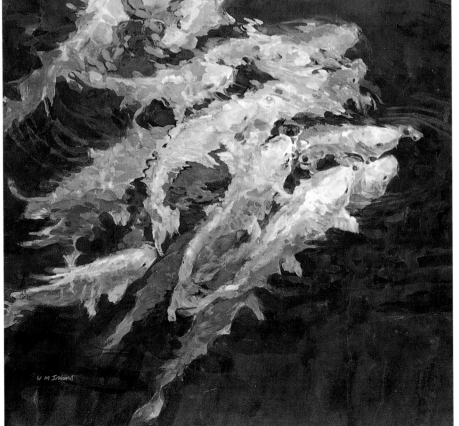
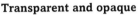

Impasto effects

Gouache can be used thickly, much like oil paints, with the advantage that it dries far more quickly. Here the artist was fascinated by the colors in the water and wanted a water-based medium to capture the shimmering, elusive quality of the fish. The gouache gives the painting a richness and density of tone not possible with transparent techniques.

GALLERY OF TECHNIQUES

THE RANGE OF TECHNIQUES available to the watercolor painter is limited only by the imagination of the individual artist, so you will no doubt devise methods of your own for controlling and manipulating the way you apply the paint. But there are particular techniques associated with the medium that range from the way washes are applied, to sponging and scratching out, washing off, wet-in-wet manipulations, and various methods of masking out. Artists have tried everything from toothbrushes to windshield wipers to create interesting effects.

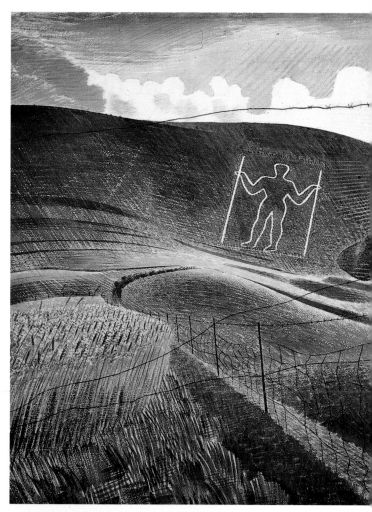

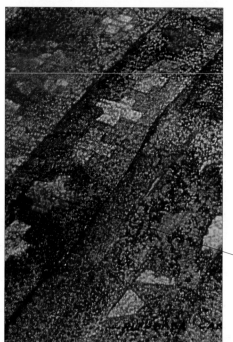

Note how pattern features throughout this painting, even down to the repeated elements on the rugs. The colors are both muted and vibrant, with an extraordinary richness due to a technique O'Reilly has devised. He has added certain inks and gums to the paint to heighten the textural effects and to give a sense of three-dimensionality to the kilims.

Philip O'Reilly, *Ali Baba Carpet Shop, Kusadasi*
This painting creates pattern through texture and vivid tonal contrasts. Contrary to conventional practice, O'Reilly likes to build up his paintings from dark to light, so that the view from the window here and the sun-drenched rug were his final touches.

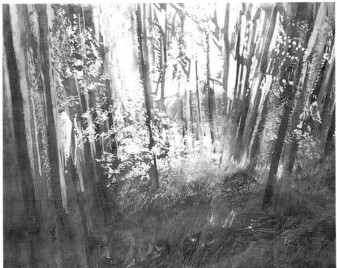

Philip Fraser, *Glade in Wood*
This work relies entirely for its effects on the use of masking fluid. Here you can see the characteristic hard-edged shape that shows where the dried masking fluid has protected the paper from the paint, creating suffused areas of light and color.

Eric Ravilious,
The Wilmington Giant, 1939
Here a real sense of scale is created by showing the wire fence large in the foreground, then disappearing into the distance – at which point the massive figure of the chalk giant rises across the Sussex Downs of southern England. The work is characterized by the use of wax resist: the watercolor is repelled in those areas shaded by the wax.

The roof was painted later with a mixture of traditional watercolor and gouache. It is the gouache that gives the color its density.

The window details were masked at an early stage to retain the fine lines and clarity of outline.

Paul Newland,
Screen and Light
This unassuming yet atmospheric study in low-key color explores the idea of pattern and shape. The technique involves floating simple flat color washes into designated areas of the painting. Other areas are left unpainted, so it is the paper itself that creates the strong sense of sunlight.

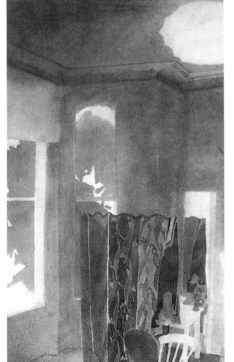

Colin Kent,
Evening Cottage
Fascinated by textures and techniques, Kent chooses smooth paper so that he can create his own surfaces with the paint and with particular methods of application. In this painting he used a pen for the blades of grass, a wallpaper brush for the sky, and a paint-soaked rag for some other areas. He has even been known to use windshield wipers if they achieve the desired effect.

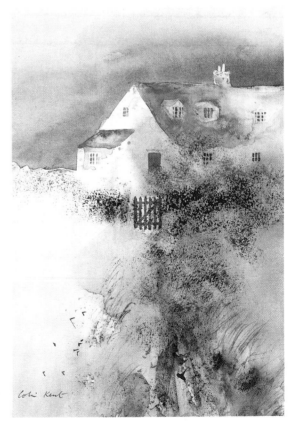

GLOSSARY

ABSORBENCY The degree to which the paper absorbs the paint, often due to the amount of surface sizing.

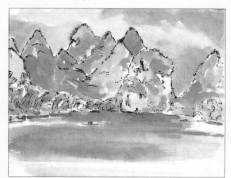

A highly absorbent, unsized paper

ACID-FREE PAPER Paper with a neutral pH that will not darken excessively with age.

ACRYLIC Synthetic resin used in an emulsion as the binding medium for artists' acrylic colors.

ADJACENT COLORS Literally, those colors closest to each other on the color wheel, but also used to describe colors that lie next to each other in a painting. Adjacent complementary colors appear brighter because each reinforces the effect of the other.

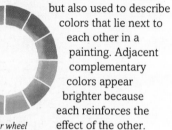

Color wheel

ADVANCING COLOR The perception of a color, usually a warm (orange/red) color, as being close to the viewer.

AERIAL PERSPECTIVE The effect of atmospheric conditions on our perception of the tone and color of distant objects. As objects recede toward the horizon, they appear lighter in tone and more blue.

AFTERIMAGE In painting, the visual effect that results from looking at a strong color, *i.e.,* perceiving the complementary color of the color we have just been looking at. If, for example, we look hard at an orange-red area and then look at a bright yellow, we might see the yellow as green because we are carrying a blue afterimage of the orange-red. This effect is known as color irradiation.

ARTISTS'-QUALITY WATERCOLOR PAINTS The best-quality paints, with high pigment loading and strong colors.

BINDER In a paint, this is the substance that holds the pigment particles together and that allows them to attach to the support. In the case of watercolor, the binder is water-soluble gum.

BLEEDING The tendency of some organic pigments to migrate through a superimposed layer of paint.

BLENDING A soft, gradual transition from one color or tone to another.

BODYCOLOR Also called gouache. A type of paint or painting technique characterized by its opacity.

BURNISHER Traditionally, a piece of polished stone such as agate has been used to burnish gold leaf and similar materials. In watercolor painting, a burnisher is used to smooth down the fibers of the paper when these have been raised by vigorous handling. Some artists use the back of a fingernail for this purpose.

CAMERA LUCIDA A drawing aid invented in the early 19th century and still used by some artists. This is a simple prism with a lens and eyepiece on a stand. With this instrument it is possible to see the subject of a painting directed down onto the watercolor paper. The artist can then draw the outlines.

CAMERA OBSCURA A development of the pinhole camera effect in which an inverted image is formed when rays of light pass through a tiny aperture. By substituting the pinhole for a lens, and using a portable screen for viewing an image, artists found that they could transcribe a scene accurately onto their drawing paper.

CANNON A cylindrical container used to measure the hairs for brushes.

CHARCOAL Carbonized wood made by charring willow, vine, or other twigs in airtight containers. Charcoal is one of the oldest drawing materials.

CHROMA The intensity or saturation of a color.

CHROMATIC Drawn or painted in a range of colors.

CLAUDE GLASS *see* Reducing glass

COLOR IRRADIATION The aftereffect that results from looking at a very strong color in which you perceive its complementary color. *See also* Afterimage

COLOR TEMPERATURE A measurement of color in degrees Kelvin. This is of importance to photographers who need to correlate the color temperature of a light source with the type of film they use. As artists, we are aware that the color temperature of a room illuminated by electric light is significantly different from (yellower than) that of daylight.

COMPLEMENTARY COLORS Those colors of maximum contrast, opposite each other on the color wheel. For example, the complementary color of a primary color is the mixture of the other two primaries, i.e., green is the complementary of red because it is made up of yellow and blue, and purple is the complementary of yellow because it is made up of red and blue.

CONTÉ CRAYON A commercial drawing stick in varying degrees of hardness and in a range of black, white, and red earth colors.

COOL COLORS Generally, a color such as blue is considered cool. Distant colors appear more blue because of atmospheric effects and cool colors are therefore said to appear to recede.

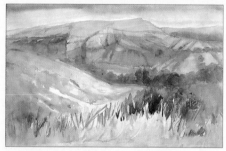

The effects of cool colors receding

DEXTRIN Starch made water-soluble by heating. It is used as an inexpensive alternative binder to gum arabic.

DURABILITY RATING *see* Lightfastness

EASEL A frame for holding a painting while the artist works on it. Watercolor painters tend to use sketching easels of light construction. A good sketching easel allows the painting to be held securely in any position from vertical to horizontal.

ERASER A tool for removing pencil and other marks. In the past, artists used rolled bits of bread, or feathers. More recently, artists have used standard rubber erasers, soft putty rubbers, or artgum erasers, although the new plastic erasers are extremely clean and versatile.

EXTENDERS Substances such as chalk or barium sulfate are often used in the manufacture of paint, especially when a particular pigment on its own is so strong that it may cause streakiness.

FELTING In paper manufacturing, the process by which plant fibers mat together.

FERRULE The metal part of a brush, which surrounds and retains the hairs.

FINDER A rectangular hole to the scale of the artist's paper cut in a small piece of cardboard to act as a framing device. This is held up at arm's length, and the scene to be drawn or painted is viewed through it.

FIXATIVE A surface coating that prevents charcoal, chalk, and conté crayon from becoming dusty and from mixing with overlaid color.

FLAT WASH An application of an even and uniform area of tone and color.

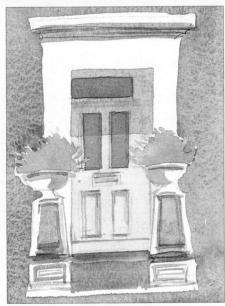

Doorway painted in flat washes

FLOCCULATION Like granulation in appearance, but the result of pigment particles coming together as a result of electrical charges rather than the coarseness of the pigment.

FLOTATION The streaky effect made by lighter pigments as they disperse unevenly on the paper.

FOCAL POINT In a painting, the main area of visual interest.

FUGITIVE Colors that are not lightfast and will fade over a period of time.

GLYCERIN The syrupy ingredient of watercolor paints, used as a humectant or moisture absorber in order to keep them moist.

GOUACHE A type of watercolor paint which is characterized by its opacity.

GOUACHE RESIST Using gouache paint or bodycolor to protect areas of your paper or paint film from further applications of paint. The gouache is subsequently washed off.

Overpainting gouache-resisted railing details

GRADED WASH A wash in which the tones move smoothly from dark to light or from light to dark.

GRANULATION The mottled effect made by heavy coarse pigments as they settle into the hollows of the paper. It may be caused by flocculation or by differences in the specific gravity of the pigments.

GRAPHITE PENCIL Standard pencil leads are made from a mixture of graphite and clay. The mixture is fired and subsequently impregnated with molten wax. The proportion of graphite to clay varies, and it is this which determines the hardness or softness of the pencil.

GRAPHITE STICK A large-scale pencil lead used for drawing.

GUM ARABIC Gum from the acacia tree used as a binding material in the manufacture of watercolor paints. Kordofan gum arabic, which takes its name from the region in Sudan from which it comes, is the main type used nowadays.

GUM ARABIC RESIST Covering details of your painting with gum arabic solution to protect the paper or paint film from further applications of paint. The gum arabic is subsequently washed off. Alternatively, mixing gum arabic with paint allows you to lift the paint off more easily later.

"HARD" WATERCOLORS Blocks of straight pigment and gum mixes with no added plasticizer or humectant (such as honey or glycerin), which were used by early watercolor artists. The blocks had to be scrubbed to get the color out but once the paint had dried, it could be painted over with little danger of dissolving the paint film.

HEEL OF BRUSH The base of the hairs, near the ferrule.

Heel of brush

HIGH-KEY COLOR Brilliant and saturated color.

HIGHLIGHT The lightest tone in drawing or painting. In transparent watercolor techniques on white paper, highlights are represented by the white of the paper. In opaque techniques, highlights are represented with opaque white gouache or bodycolor.

HP OR HOT-PRESSED Paper with a very smooth surface.

HUE Description of a color such as red.

HUMECTANT A moisture-absorbing additive, such as glycerin, which is added to watercolors to keep them moist.

IMPASTO A thick application of paint.

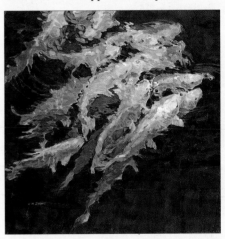

A thick, painterly application of gouache paint

INTERNAL SIZING A means of reducing the natural absorbency of paper by adding sizing at the pulp stage. *See also* Sizing and Surface sizing

LAID PAPER Paper in which you can detect a ladderlike, horizontal and vertical pattern due to the pattern of the wire mold on which it was made.

LATEX *see* Masking fluid

LIFTING OUT The technique used to modify color and create highlights by taking color off the paper using a brush or sponge.

LIGHTFASTNESS Permanence (or durability) of a color measured by the American Standard Test Measure (ASTM) in the United States, in which the most permanent colors rate 1 or 2. The equivalent institute in Great Britain, the Blue Wool Scale, rates the most permanent colors at 7 or 8.

LOW-KEY COLOR Muted or unsaturated color. *See also* High-key Color

MASKING FLUID A solution of latex in ammonia used for masking out particular areas in a painting. It is available in white or pale yellow; when using white paper, it is easier to see where the pale yellow has been painted on, although there is a very slight risk that the colored masking fluid will stain the paper.

MASKING OUT The technique of using masking fluid or other materials to protect areas of the watercolor paper while adding washes. With masking fluid, the solution is allowed to dry, paint is applied over it and once that has dried, the masking fluid is gently peeled off.

MONOCHROMATIC Drawn or painted in shades of one color.

MONOFILAMENTS Individual strands of manufactured fiber.

MOLD-MADE PAPER The most common form of high-quality watercolor paper is made on a cylinder mold machine. The more random arrangement of the fibers in this process as compared with that on commercial machine-made paper gives far greater strength and dimensional stability to the paper.

NICKEL TITANATE A modern inorganic yellow pigment of great permanence.

NOT OR COLD-PRESSED Paper with a fine grain or semi-rough surface.

OPTICAL MIX Color achieved by the visual effect of overlaying *(right)* or abutting (placing next to each other) distinct colors, rather than by mixing them in a palette.

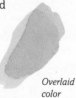
Overlaid color

ORIENTAL PAPER Highly absorbent, handmade paper with no internal or surface sizing. Some Japanese papers can weigh as little as 12 gsm.

A panoramic vista on Korean paper

OVERLAYING WASHES The technique of painting one wash over another in order to build up a depth of color or tone.

OXGALL A wetting agent that helps the paint flow more easily on the paper.

PERSPECTIVE The method of representing three dimensions on a two-dimensional surface. Linear perspective makes objects appear smaller as they get farther away by means of a geometric system of measurement. Aerial perspective creates a sense of depth by using cooler, paler colors in the distance, and warmer, brighter colors in the foreground.

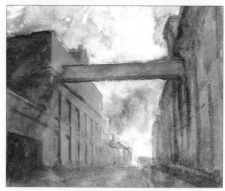
Linear perspective: distant buildings appear smaller

PHTHALOCYANINE Modern organic transparent blue and green (chlorinated copper phthalocyanine) pigments of high tinting strengths and excellent lightfastness. Also known by trade names.

PHYSICAL MIX When a color is arrived at by mixing together several colors on the palette before applying it to the paper.

PIGMENT Solid-colored material in the form of discrete particles that form the basic component of all types of paint.

PRESERVATIVE Substance added to painting materials to act as a fungicide and bactericide. This is particularly important in watercolor because the paints are prone to microbiological growth.

PRIMARY COLORS The three colors, red, blue, and yellow, which cannot be produced by mixing other colors and which, in different combinations, form the basis of all the other colors.

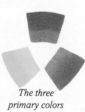
The three primary colors

QUINACRIDONE A modern organic transparent red pigment with very good lightfastness.

RECEDING COLOR The perception of a color, usually a cool (blue), as being distant from the viewer.

REDUCING GLASS A drawing aid, also known as a Claude glass, used extensively in the 18th and 19th centuries. A small tinted convex mirror reflects a reduced and largely monochromatic image of the landscape.

RESIST A method of preventing the paint from coming into contact with the paper or the layer of paint film by interposing a protective coating. Used to preserve highlights, for example, or to retain a particular color.

ROUGH OR COLD-PRESSED Paper with a rough surface.

S'GRAFFITO A technique, usually involving a scalpel or sharp knife, in which dried paint is scraped off of the painted surface. Often used for textural effects.

SABLE Mink tail hair used to make fine watercolor brushes.

SATURATION The degree of intensity of a color. Colors can be saturated, i.e., vivid and of intense hue, or unsaturated (sometimes known as desaturated), i.e., dull, tending toward gray.

SCRATCHING OUT Similar to s'graffito, the process of scratching the surface of the paint (wet or dry) to reveal the paint film or paper that lies below. Can be done with a blade or, in wet paint, with the handle of the brush.

Getting back to the paper surface

SECONDARY COLORS Green, orange, and purple, the colors arrived at by mixing two primaries and which lie between them on the color wheel.

SIZING The coating, either internal or external, of paper. Prepared size usually contains a mixture of gelatin, water, and a preservative. The sizing affects the hardness and absorbency of the paper and consequently the way in which the paint will react on it.

SIZING, NEUTRAL A modern size with a neutral pH that replaces the earlier, more acidic, sizing materials.

SKETCHING UMBRELLA A large umbrella designed to provide shade and shelter for the artist when working outdoors. It has a spiked handle, so that it can be stuck into the ground firmly.

SPATTERING A technique that involves flicking paint off of the hairs of a bristle brush or a toothbrush with your nail to create an irregular pattern of paint.

SPONGING OUT The technique of soaking up paint with a sponge or paper towel so that areas of pigment are lightened or removed from the paper. Can be used to rectify mistakes or to create particular effects.

Creating clouds by sponging out paint

SQUARING UP A grid system used to transfer a sketch or other image accurately to the painting surface. A square grid is superimposed onto the sketch and replicated on the painting surface – often on a larger scale. Complicated areas, as in the girls' faces below, can be given a more detailed grid. The image is then copied square by square from the original image onto the painting surface.

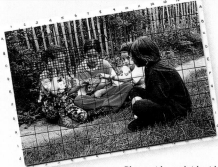

Photo with overlaid grid

STAINING POWER The degree to which a pigment stains the paper and resists being washed off or scrubbed out. *See also* Tinting Strength

STENCIL An image cut out of cardboard or another material. Paint can be sponged or sprayed through the cutout.

STIPPLING A method of painting involving the application of tiny dots of color with the tip of the brush.

STRETCHING PAPER The process by which watercolor paper is stretched to prevent it from buckling when paint is applied. The paper is wetted by sponging or dipping briefly in water, attached to a board with masking tape, and allowed to dry.

SURFACE The texture of the paper. In Western papers – as opposed to Oriental – the three standard grades of surface are Rough, Hot-pressed (smooth) and NOT or Cold-pressed (semi-rough).

SURFACE SIZING A means of decreasing the absorbency of a painting surface. Commercially available artists' quality watercolor paints are invariably surface-sized in warm gelatin to allow the paper to withstand vigorous treatment.

TERTIARY COLORS Colors that contain all three primaries.

TINT Color mixed with white. In the case of watercolor, a similar effect is achieved by thinning the paint with water and allowing more of the white surface of the paper to reflect through it.

TINTING STRENGTH The strength of a particular color or pigment.

TOE OF BRUSH The tip of the hairs.

TONE The degree of darkness or lightness of a color. Crumpling a piece of white paper allows you to see a range of tonal contrast.

Tonal values of white

VARIEGATED WASH A wash in which different colors have been applied in such a way that they run into one another.

VIEWER *see* Finder

WARM COLOR Generally, a color such as orange-red is considered warm. In accordance with atmospheric or aerial perspective, warm colors appear to advance toward the viewer, whereas cool colors appear to recede.

WASHING OFF The process of dislodging an area of paint, possible with a bristle brush dipped in water, or a damp sponge.

WATERLEAF A paper with no internal sizing, and which is consequently highly absorbent.

WAX RESIST The process by which wax crayons or a sliver of a candle are used to protect areas of the paper or paint film from further applications of paint.

WEIGHT Watercolor paper is measured in lbs (pounds per ream) or gsm (grams per square meter). It comes in a large range of weights, although the standard machine-made ones are 90 lb (190 gsm), 140 lb (300 gsm), 260 lb (356 gsm), and 300 lb (638 gsm). The heavier papers, 260lb and over, generally do not need stretching.

WET-IN-WET Working with wet paint into wet paint on the surface of the paper.

Wet-in-wet technique

WOOD-FREE PAPER Good-quality paper made from purified, acid-free wood pulp that does not yellow with age.

WOVE PAPER Paper in which you can detect the pattern of the wire mold on which it was made, giving it a woven appearance.

A NOTE ON COLORS, PIGMENTS, AND TOXICITY

In recommending Winsor Blue and Winsor Green (which are trade names of the Winsor & Newton Company), we are recommending "phthalocyanine" pigments; other artists' material manufacturers refer to them by their own trade names. These include Phthalo Blue and Green, Monestial Blue and Green, and so on. Similarly, in recommending Permanent Rose, we are recommending a "quinacridone" pigment. Lemon Yellow Hue, another of our recommended pigments, is also known as Nickel Titanate Yellow. If you have any doubts about which pigment you are buying, refer to the manufacturer's literature.

We have tried to avoid recommending pigments, such as the Chrome colors, which carry a significant health risk. In the case of colors such as the Cadmiums, however, there is nothing commercially available that matches them for color and permanence. But there is no danger in their use nor in that of other pigments provided artists take sensible precautions and avoid licking brushes with paint on them.

A NOTE ON BRUSHES

The brush sizes given here refer to Winsor & Newton brushes. They may vary slightly from those of other manufacturers.

A NOTE ON PAPERS

The surfaces of papers – Rough, Hot-pressed, and NOT (semi-rough) – vary noticeably from one manufacturer to another so it is worth considering several before deciding which to buy.

INDEX

ACKNOWLEDGMENTS

Ray Smith would like to thank Alun Foster and Richard Goodban of Winsor & Newton Ltd, for their expert advice and Jane Gifford for her lovely fresh paintings. Many thanks also to the team at Dorling Kindersley, including Jane Laing, Sean Moore, Tina Vaughan, Gwen Edmonds, and Toni Kay, and in particular to my editor, Emma Foa, for her patience and skill in managing to get a quart into a pint pot, and to Claire Legemah for her lively and beguiling approach to the design.

Thanks also to Nigel Partridge for his design help; to Maria D'Orsi for design assistance; and to Constance Novis for Americanizing the text.

Picture credits

Key: t=top, b=bottom, c=center, l=left, r=right

Endpapers: Jane Gifford; *p1:* Gabriella Baldwin-Purry; *p2:* Philip O'Reilly; *p3:* all, Julia Rowntree; *p4:* Camilla Smith, aged 7, dedicated to her father, Ray; *p5:* paint swatches Sharon Finmark; figures Jane Gifford; materials Winsor & Newton; *pp6/7:* carnations Sharon Finmark; others Gabriella Baldwin-Purry; *pp8/9:* Dürer, British Museum/Bridgeman Art Library; Girtin, Tate Gallery/Bridgeman Art Library; Turner, British Museum/Bridgeman Art Library; Cozens, Private Collection/Bridgeman Art Library; Constable, by Courtesy of the Board of Trustees of the V & A/ Bridgeman Art Library; *pp10/11:* Pissarro, British Museum/Bridgeman Art Library; Cotman, Bonhams/Bridgeman Art Library; Sargent, by Courtesy of the Board of Trustees of the V & A/Bridgeman Art Library; Hopper, Whitney Museum of American Art, New York/Bridgeman Art Library; Palmer, Odham Art Gallery, Oldham; *pp12/13:* all, Winsor & Newton; *pp14/15:* color wheel and boxed swatches, Ray Smith; others Sharon Finmark; *pp16/17:* all, Ray Smith; *pp18/19:* all, Sharon Finmark; *p20:* Will Adams;

p21: t Sharon Finmark; b Jane Gifford; *p23:* Nolde (attr.), Ruttebüll Tief, Christie's, London/Bridgman Art Library, © Nolde-Stiftung Seebüll; *p24:* Winsor & Newton; *p25:* Ray Smith; *pp26/27:* all, Jane Gifford; *pp28/29:* all, Julia Rowntree; *p31:* Dufy, Visual Art Library, London; *p32:* sketchbook Jane Gifford; cylinder mold machine and Bockingford tinted paper, Inveresk, St.Cuthberts Paper Mill; *p34:* t Sharon Finmark; *p35:* Jane Gifford; *pp36/37:* Klee, Christie's, London/Bridgeman Art Library; *pp38/39:* portrait, Ray Smith; others, Julia Rowntree; *p40:* t Julia Rowntree; *p41:* Maria D'Orsi; *pp42/43:* all, Sharon Finmark; *p44:* Ray Smith; *p45:* t Sharon Finmark; b Jane Gifford; *pp46/47:* all, Sharon Finmark; *pp48/49:* beach scenes, Julian Gregg; others, Ray Smith; *p50:* Cotman, Oldham Art Gallery, Oldham; *pp52-55:* all, Julia Rowntree; *p64:* t Ray Smith; bl&r Sharon Finmark; *p65:* t Sharon Finmark; b William Ireland; *pp66/67:* Ravilious, Private Collection/Bridgeman Art Library; *p68:* tl Jane Gifford; ml Ray Smith; mr Sharon Finmark; *p69:* l Sharon Finmark; tc Julia Rowntree; r William Ireland; *p70:* tl Ray Smith; bl Jane Gifford; c Tim Pond; r Julia Rowntree; *p71:* tl Ray Smith; tr Sharon Finmark.